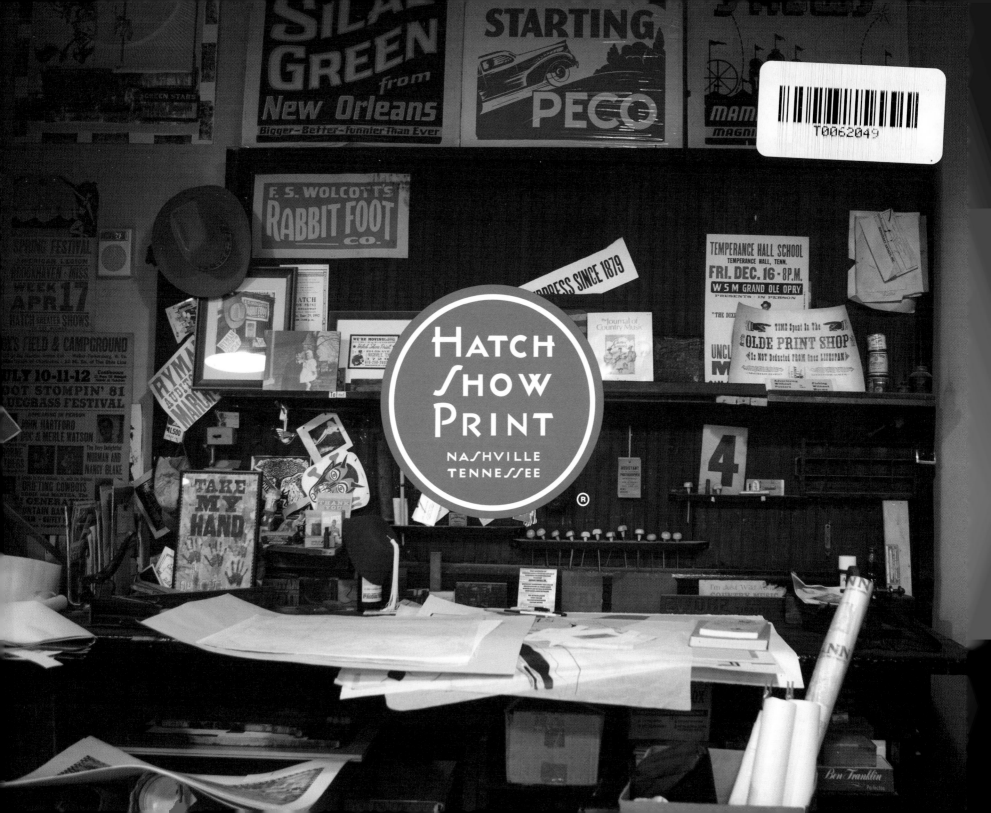

COMING SOON

WSM GRAND OLE OPRY

GRAND OLE OPRY

Country Music Foundation Press
222 Fifth Avenue South • Nashville, Tennessee 37203

Printed in the United States of America.

978-0-915608-34-8

Produced by the staff of the Country Music Hall of Fame® and Museum

Written by Jim Sherraden, with Celene Aubry Editor: Jay Orr Designer: Margaret Pesek
Artifact photos by Bob Delevante

This project represents the work of many Hatch Show Print and Country Music Hall of Fame and Museum
staff members. Space prohibits listing them all, but the contributions of printer-designers Heather Moulder and
Jennifer Bronstein, Senior Creative Director Warren Denney, Associate Director of Quality Control Chris Richards,
and copy editor Nicole Childrey deserve special mention.

Background: An array of metal and hand-carved wood nameplates used to produce show posters for members of the Grand Ole Opry.

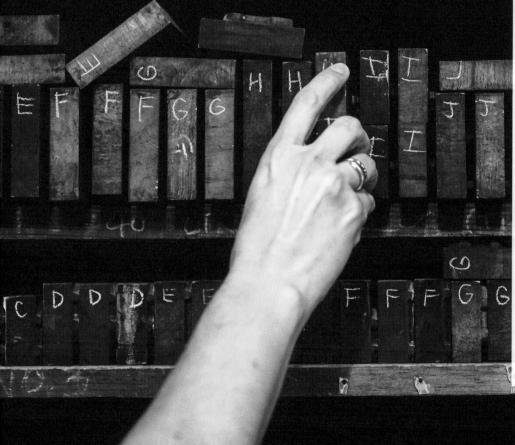

CONTENTS

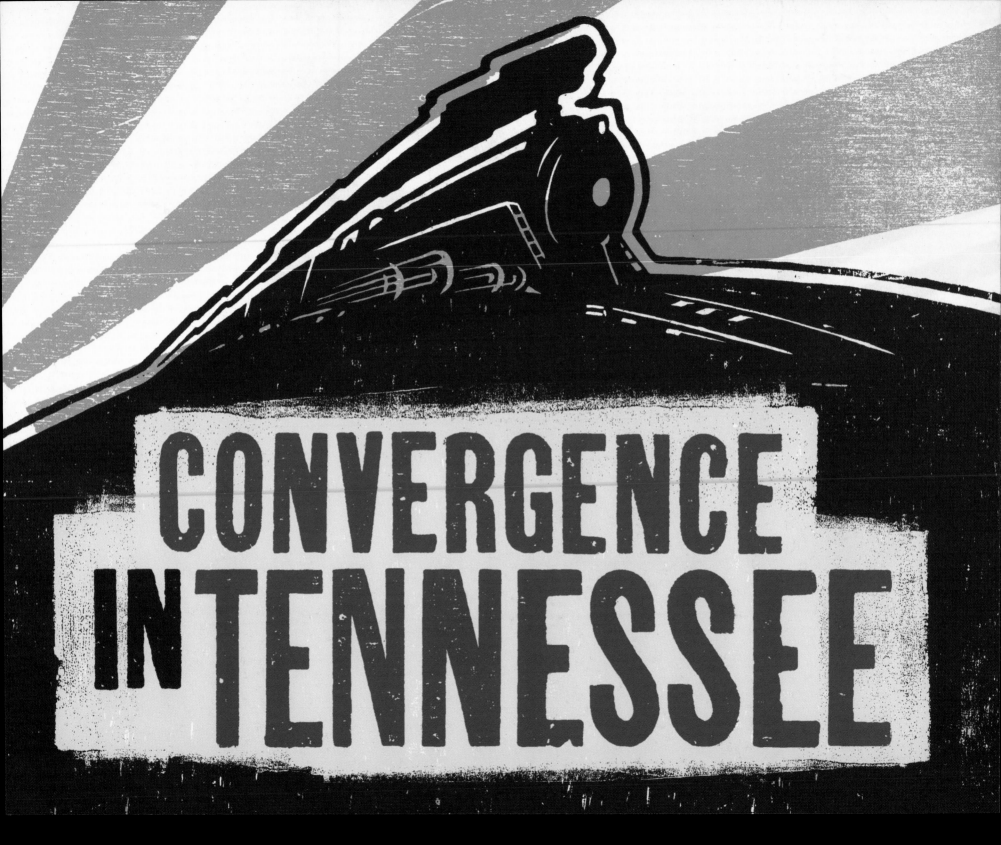

TEMPERANCE HALL SCHOOL

TEMPERANCE HALL, TENN.

FRI. DEC. 16 · 8 P.M.

WSM GRAND OLE OPRY

PRESENTS - IN PERSON

"THE · DIXIE DEWDROP"

UNCLE DAVE MACON

WITH

SAM & KIRK MCGEE From Sunny TENNESSEE

RESTRIKE OF ORIGINAL DESIGN HATCH SHOW PRINT® 2013

Country Music Hall of Fame member Uncle Dave Macon surely must have been one of the most faithful of the many entertainers who patronized Hatch Show Print in the early years of the poster-printing shop's existence.

A native Tennessean, Macon spent his formative years living in his parents' Nashville boarding hotel. He learned tricks and stories and jokes, and how to play the banjo with zany abandon, from the many itinerant veterans of vaudeville and traveling circuses who passed through its doors. Born in 1870, Macon was not many years older than Hatch Show Print. Brothers Charles R. Hatch and Herbert H. Hatch—Wisconsin transplants—opened their printing business in 1879.

Macon emerged as a professional entertainer in the 1920s, building his audience while hauling freight around middle Tennessee. As his fan base grew, and he ventured further afield, Macon came to depend on Hatch Show Print as an important part of his team. Macon used the shop's posters, each printed by hand, to advertise upcoming appearances, to build his profile as a showman, and to enhance recognition of the "Uncle Dave" brand. The earliest shop records that exist, from 1938, suggest that Macon did business with the shop on a regular basis.

2013 restrike of an Uncle Dave Macon poster

If Macon was a Hatch Show Print believer, though, he had plenty of company. Harmonica ace and future Country Music Hall of Fame member DeFord Bailey toured with Macon in the 1930s, and Bailey's image appears on posters from the shop. Representatives from the RCA Victor record company came to Nashville in 1928 to record, and they captured stringbands from the Opry, such as the Binkley Brothers' Clodhoppers and the Crook Brothers' String Band. Those old-time ensembles might have relied on Hatch Show Print for posters that inspired paying customers to attend their shows.

The handsome visage of Eddy Arnold—the "Tennessee Plowboy"—adorned posters from Hatch Show Print during his early career. He had worked with Pee Wee King's Golden West Cowboys, but launched a solo career in 1943, traveling that summer in a tent show with gospel singers the John Daniel Quartet.

Arnold made his first professional recordings in Nashville, in December 1944, and he was on his way. Hatch Show Print, on the other hand, had by that time logged sixty-five years of working with early country players and pickers, producing thousands of posters for artists who eventually would be identified as country musicians.

Above: Package show including the John Daniel Quartet. The Jordanaires, who formed in 1948, went on to become members of the Country Music Hall of Fame.

Left: DeFord Bailey poster, c. 1960. Among the first Opry regulars who grasped the utility of posters, Bailey later became a member of the Country Music Hall of Fame.

Hatch Show Print existed in Nashville well before the country music business sprouted there. As if by design, the print shop moved into its first purpose-built printing plant, at 116 Fourth Avenue North, in 1924. The Grand Ole Opry got its start the following year, as WSM Radio's "Barn Dance," and grew so popular that it had to move in 1943 into the cavernous Ryman Auditorium, next door to Hatch Show Print, at 116 Fifth Avenue North. On warm Saturday nights in the summer, when print shop windows and Ryman windows were open, the printers could hear the pickers as the music wafted across the street on the breeze.

Opry entertainers often appeared larger than life to fans—especially on large-format Hatch Show Print posters depicting their image—but they were, by and large, everyday country people with special talents that seemed to promise greatness. Many of the Opry stars who visited the Hatch Show Print shop were on a first-name basis with the staff—a quick flip through the old Rolodex reveals telephone numbers and addresses for Country Music Hall of Fame members Pee Wee King and Bill Monroe.

Those performers became regular patrons of the shop. Advertising an upcoming performance with a poster from Hatch Show Print was as essential as the electricity amplifying the instruments.

Poster, c. 1958

MAKING A HATCH POSTER

In letterpress printing, raised, inked surfaces—usually made of wood, metal, or linoleum—are pressed onto paper. The practice is essentially the same method of relief printing as the one invented in the fifteenth century by Johannes Gutenberg, using movable, hand-set type, hand-carved blocks, and hand-cranked printing presses.

Today, Hatch Show Print creates posters the same way they were made 140 years ago. Designs carved on wood blocks combine with movable letters of wood or metal. These elements are positioned backwards, and locked into a frame, or "chase," secured in a printing press, and inked. The paper is pressed onto the inked type to obtain an impression that is right-reading. Posters with more than one color require separate assemblages, or "forms," for each color. Each application of additional color requires a new pass of the paper through the press.

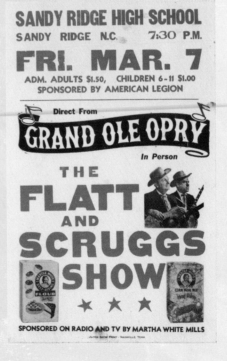

Right, clockwise from upper left:

Each line of the poster is typeset by hand.

Wood and metal type, photoplates, and hand-carved image blocks are all used in the design and layout of a Hatch Show Print poster.

Each poster is printed one color at a time, one piece of paper at a time.

The shop uses cylinder presses to print the posters.

Left: Restrike of 1969 poster

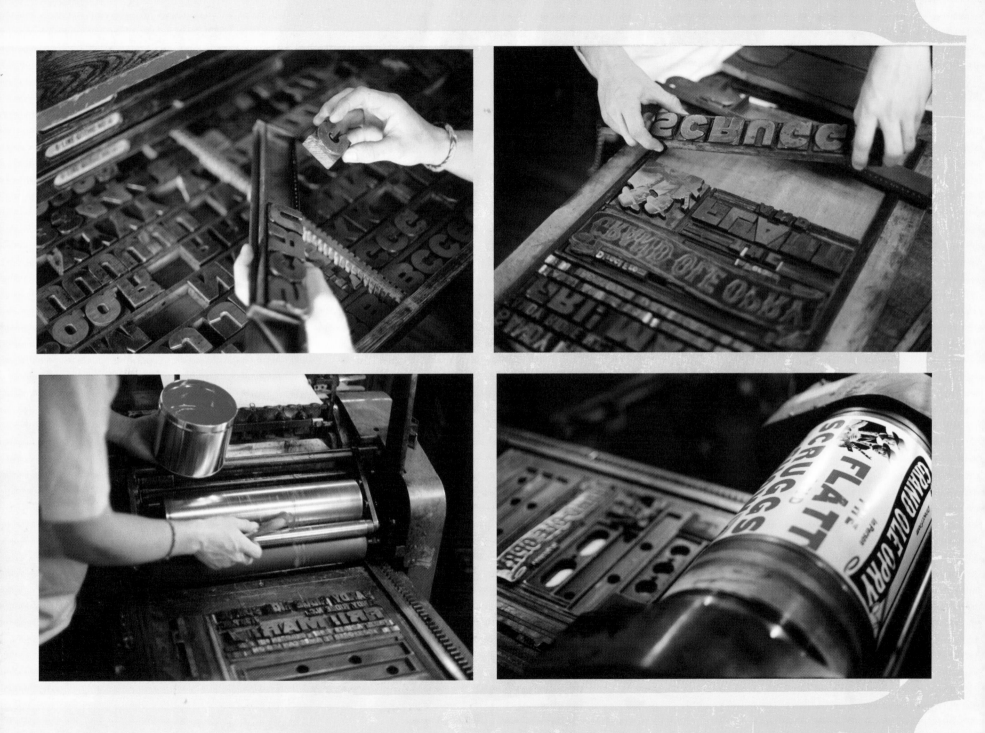

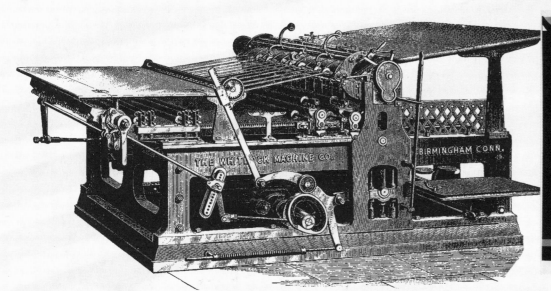

Since 1879, Nashville's Hatch Show Print has provided posters to thousands of entertainers looking to inform the public about an upcoming performance. That makes the shop one of the oldest letterpress operations in the United States. It has deep stores of movable wood type and carved wood and linoleum blocks, and after five generations of near-constant use by designers and printers producing posters, Hatch Show Print has become a bona fide analog institution, surviving and thriving into the digital age. The shop now occupies its sixth location: an appropriate spot, inside the Country Music Hall of Fame and Museum.

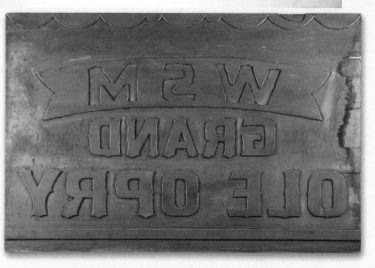

Upper left: The Whitlock flatbed cylinder press depicted in this nineteenth-century engraving is among the many presses used at Hatch Show Print through the years.

Above: This large c. 1940s Grand Ole Opry wood block would have been printed on a Babcock Optimus 6.

Left: The shop started using motorized Vandercook proof presses in the 1980s. This calendar cover would have been printed on such a press.

12

In the days when posters were used primarily for advertising, people known as "bill posters" would routinely leave the shop with prints tucked under their arms, heading off to advertise an event *before* it took place. These days, Hatch Show Print posters leave the concert venue under a concertgoer's arm *after* the show— a commemorative item celebrating the evening. The shop produces over 600 poster jobs each year—many of them for country performers, totaling roughly 250,000 posters printed on ten presses.

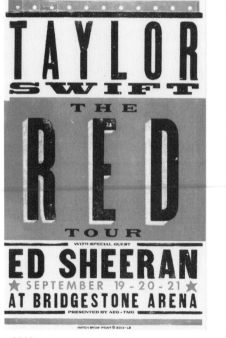

2013

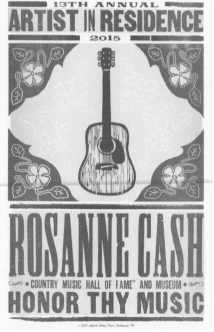

2015

Today, show posters produced at Hatch Show Print commemorate a performance, and are sold at the merchandise table or presented to the artists and crew as gifts.

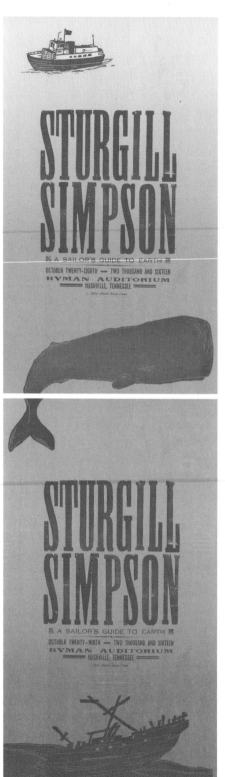

2016

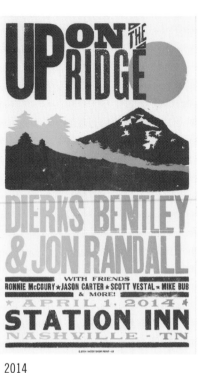

2014

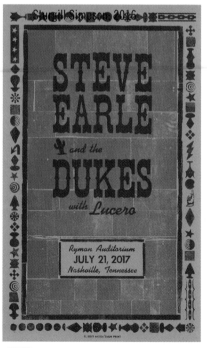

2017

2016

Like the early stars of the Grand Ole Opry, many modern performers earn a share of their living on the road. With streaming and digital media cutting into album sales, many also enhance their earnings by offering a variety of merchandise—and a show poster is a tactile memento of a memorable evening.

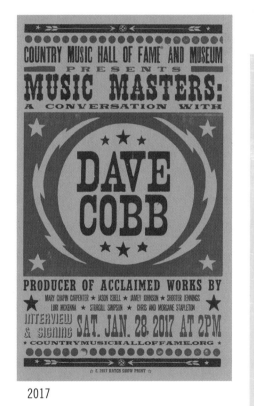

2017

2014

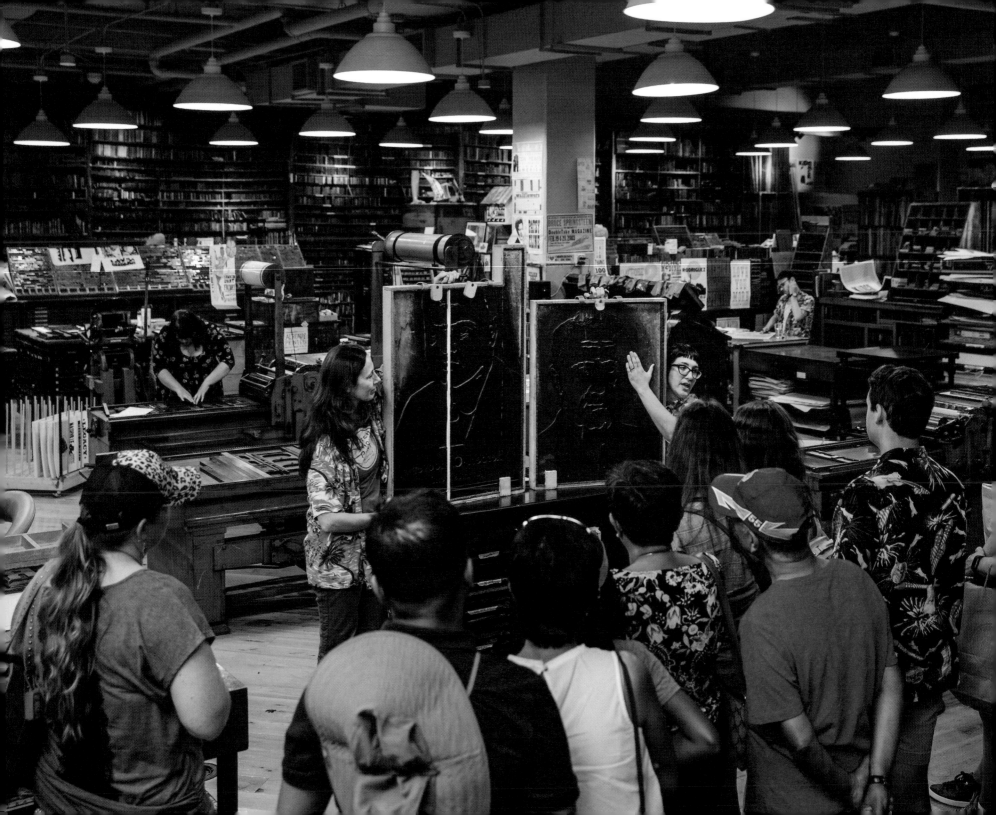

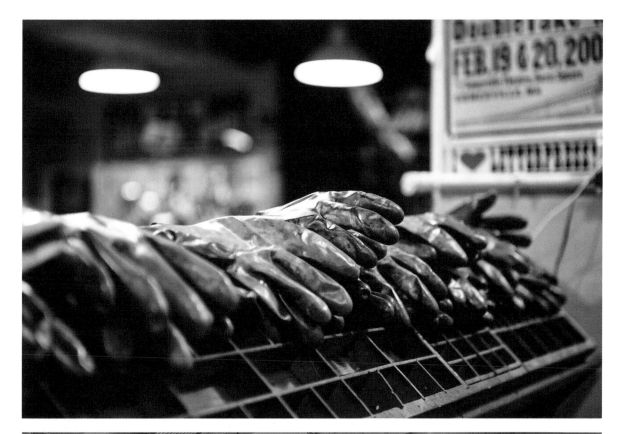

The artist who designs a poster also prints it, and the shop only produces work designed in the shop by its highly trained designer-printers. A team of educators leads activities for all ages, in the shop's classroom and in the outside community. Each year, new interns work shoulder-to-shoulder with the staff to learn the craft of poster-making, carrying the tradition forward.

The shop has its own retail store and gallery—the Haley Gallery—to better celebrate the rich heritage of letterpress printing, which thrives in the mecca of country music.

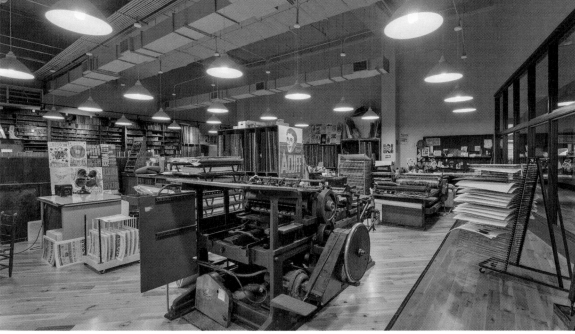

Opposite: Many consider the technology used by Hatch Show Print to be outmoded by at least two evolutions: from letterpress printing to offset printing, and from offset printing to digital printing. So the process has become a curiosity. Visitors from around the world come to the shop each day to learn about Hatch Show Print's history and the traditions of letterpress printing, often while the staff carries on with work.

Above left: A pair of gloves for each designer-printer—details of life in a letterpress print shop.

Left: Printing presses, built from 1900 to the 1960s, share the most visible area of the shop, adjacent to an eighty-foot-long wall of windows. Visitors can watch the freshly inked posters coming off the presses.

FROM ⟶
COBBLESTONE
TO PRINTERS' ALLEY

Market Street (now Second Avenue), Nashville, Tennessee, c. 1875
Courtesy of Tennessee State Library and Archives

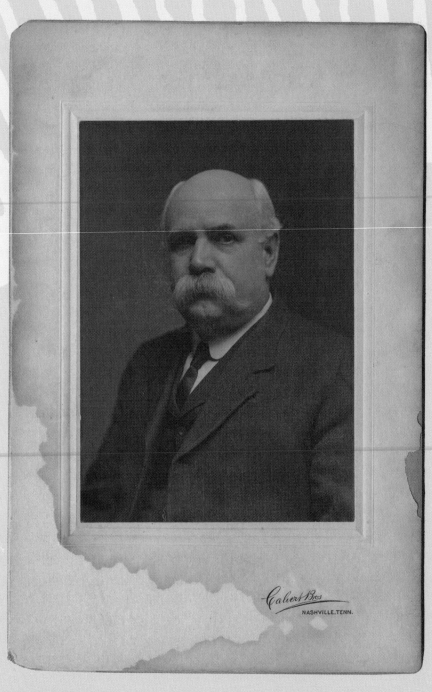

Herbert H. Hatch

Charles R. Hatch

Below: Advertisement for the shop's services, printed on December 26, 1909, in the *Nashville American*. The shop has the same telephone number today.

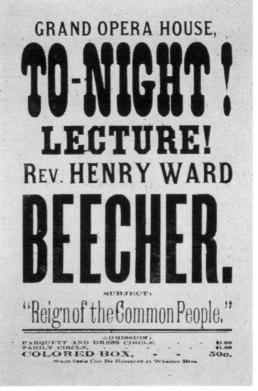

Left: The first piece printed by C. R. and H. H. Hatch, Printers, was a six-by-nine-inch "dodger," or handbill, advertising a speech by Henry Ward Beecher, brother of Harriet Beecher Stowe, on April 12, 1879.

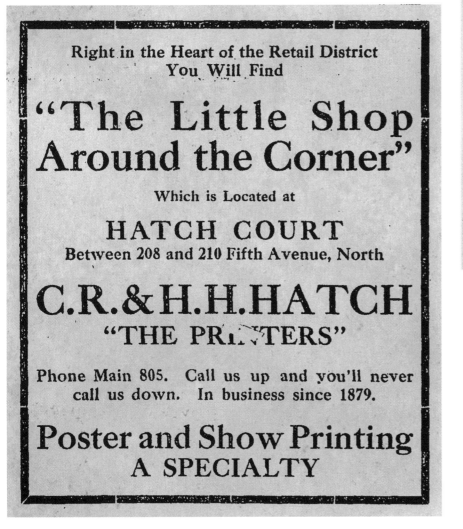

When the Hatch family arrived in Nashville from Prescott, Wisconsin, in 1875, cobblestone covered the streets, and the din of horse-drawn carriages hired as dray transport competed with the clicking of metal type being set, and the clacking of printing presses producing newspapers, posters, stationery, sheet music, Bibles, and religious publications.

Such heavy activity in the printing trade earned Nashville its reputation as a regional printing hub. By the mid-twentieth century, the city would establish itself as a center of music publishing and production, eventually taking the name Music City U.S.A., and Charles and Herbert Hatch would find themselves at the intersection of Nashville's past and present.

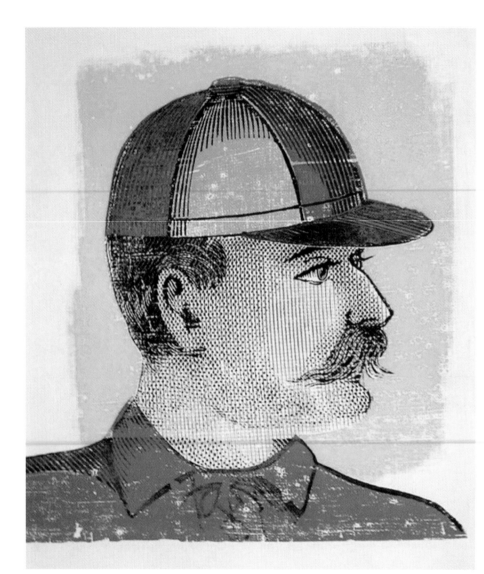

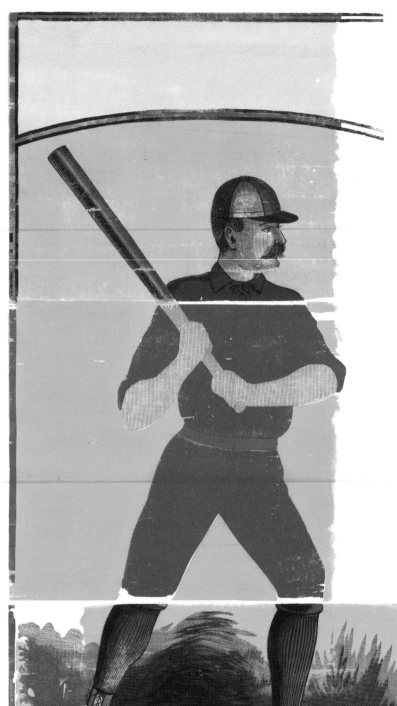

Measuring approximately forty by seventy-eight inches, this baseball player was originally printed in five colors, using fifteen blocks. The print is incomplete, as the blocks have been damaged or repurposed over the years, though a close-up of the player's head and face shows the carving detail used to create a textured, dimensional print.

The Hatch brothers came to Nashville as prepared as they could be for printing success. They had apprenticed in the printing business before leaving Wisconsin, and founded their Nashville company—C. R. & H. H. Hatch, Printers—just four years after they arrived in Nashville. They leased space in the basement of the *Nashville Banner* newspaper, on the corner of Commerce and Cherry (now Fourth Avenue North), and quickly connected with the emerging entertainment business—"Poster and Show Printing A SPECIALTY," reads a Hatch advertisement in the *Nashville American* from December 1909.

Very few posters survive from the earliest era, but clues abound about the shop's activity. A one-sheet wood block for *Silas Green from New Orleans* includes the name of the minstrel troupe's co-founder, Eph Williams, and partial blocks of a three-sheet baseball player from the late nineteenth century reinforce the shop's early reputation as a business cutting wood blocks.

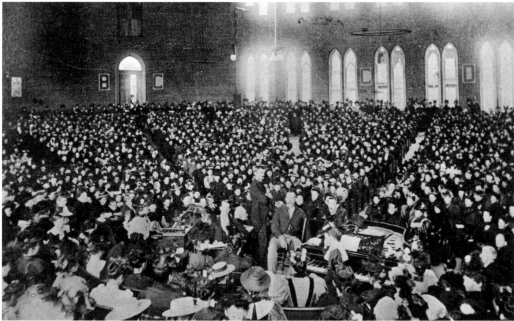

Above left: This block—featuring Ephraim "Eph" Williams, one of the original owners of the *Silas Green from New Orleans* minstrel show, established c. 1904—shows the efficiency of carving the same advertisement three times on the same block, so that each print could be cut to make three posters.

Left: An 1895 revival meeting, led by Sam Jones at the Union Gospel Tabernacle (now Ryman Auditorium). C.R. & H. H. Hatch, Printers produced the large letters hung on the walls to mark seating sections, using one sheet (approximately twenty-six by forty inches) wood type carved in the shop. *Courtesy of Tennessee State Library and Archives*

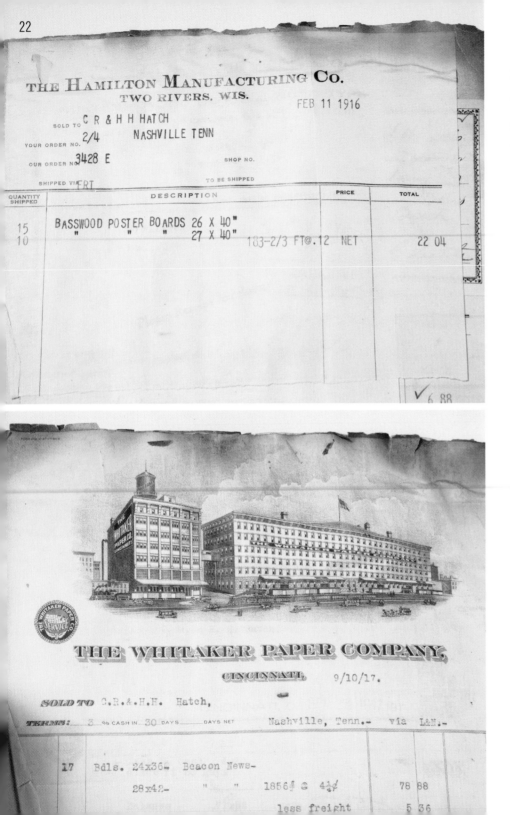

Ledgers from 1916 to 1921 reflect regular purchases of shop supplies: wood type and type-high wood block blanks (on which poster makers hand-drew imagery in reverse, then carved away the excess wood) from Hamilton Wood Type Manufacturing in Two Rivers, Wisconsin; tens of thousands of sheets of paper from the Whitaker Paper Company in Cincinnati each month; red, black, yellow, blue, and green ink from Eagle Ink Printing Company in New York, and Frank Lehman in Nashville.

The shop regularly wore out rollers on the four workhorse printing presses, producing posters that papered towns along a touring show's route. Some were on paper, some on muslin, purchased from Morgan and Hamilton Bag Manufacturer on Eighth Avenue North in Nashville. "Advance men" who picked up prints to post were given hickory bill-poster brush handles, made by L. O. Kirkpatrick & Sons Company in Nashville.

Eventually the shop occupied two addresses near the city courthouse at 415 and 417½ Deaderick Street, alongside many other enterprises committed to the printing industry. There, a print shop owner could find everything he needed by simply walking out the door. The concentration of similar businesses inspired the area's nickname, Printers' Alley. Nashville was living up to its reputation as the "Printing Capital of the South," and Hatch Show Print sat at the heart of a bustling industry, and at the feet of a growing one.

Left and opposite page: Invoices from the early twentieth century reflect purchases of type-high basswood blocks to be carved for posters, paper, and cotton muslin to print the posters on, brush handles for bill posters' glue, ink, and replacement rollers for the presses.

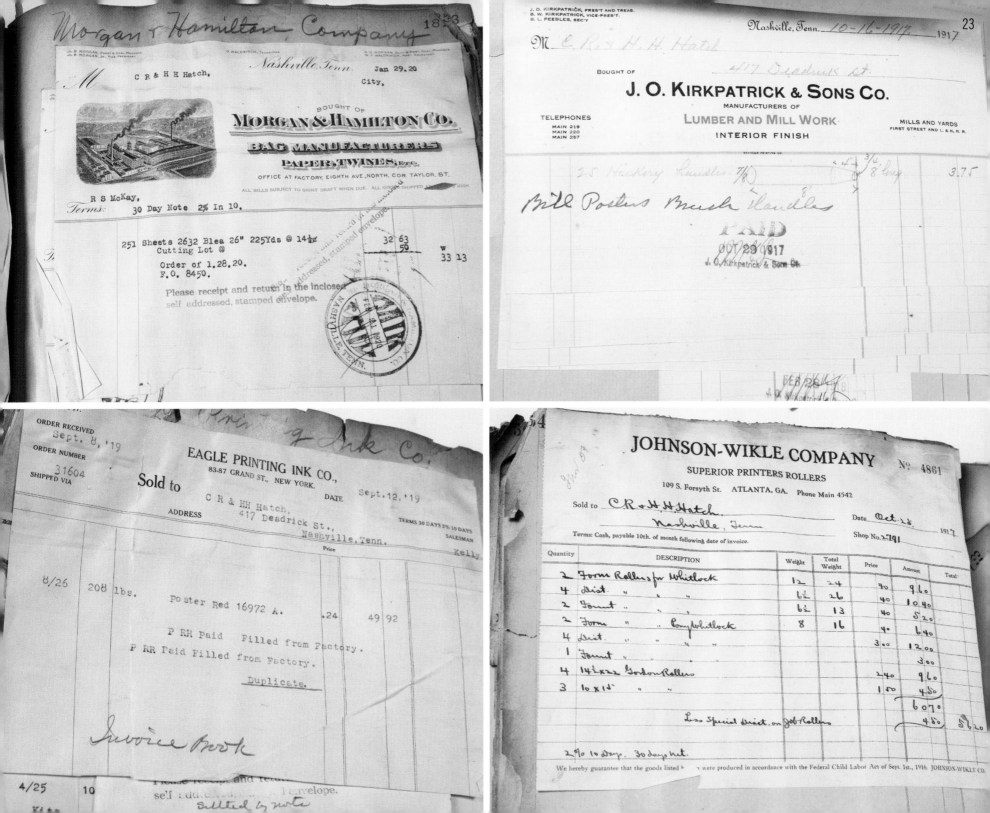

Top left — Morgan & Hamilton Company

Morgan & Hamilton Company 1833

Jo. B. MORGAN, Prest. & Genl. Manager
Jno. B. MORGAN, Jr. Vice President
G. WALDKIRCH, Treasurer
S. N. MORGAN, Genl. & Asst. Genl. Manager
W. F. WALDKIRCH, Asst. Secretary

Nashville, Tenn. Jan. 29. 20

M C R & H H Hatch,
City,

BOUGHT OF
MORGAN & HAMILTON CO.
BAG MANUFACTURERS
PAPER, TWINES, Etc.

OFFICE AT FACTORY, EIGHTH AVE., NORTH, COR. TAYLOR ST.

ALL BILLS SUBJECT TO SIGHT DRAFT WHEN DUE. ALL GOODS SHIPPED AT BUYER'S RISK.

R S McKay,
Terms: 30 Day Note 2% In 10.

251 Sheets 2632 Blea 26" 225Yds @ 14½¢	32	63
Cutting Lot @		50
	W	33 13
Order of 1.28.20.		
F. O. 8450.		

Please receipt and return in the inclosed
self addressed, stamped envelope.

Top right — J. O. Kirkpatrick & Sons Co.

23

J. O. KIRKPATRICK, PRES'T AND TREAS.
B. W. KIRKPATRICK, VICE-PRES'T.
B. L. PEEBLES, SEC'Y

Nashville, Tenn. 10-16-1917 1917

M C R & H H Hatch

BOUGHT OF 417 Deadrick St.

J. O. KIRKPATRICK & SONS CO.
MANUFACTURERS OF
LUMBER AND MILL WORK
INTERIOR FINISH

TELEPHONES
MAIN 219
MAIN 220
MAIN 257

MILLS AND YARDS
FIRST STREET AND L. & N. R. R.

25 Hickory Handles 7/8	4 ¾ 8 long	3.75

Bill Posters Brush Handles

PAID
OCT 29 1917
J. O. Kirkpatrick & Sons Co.

Bottom left — Eagle Printing Ink Co.

ORDER RECEIVED
Sept. 8, '19

ORDER NUMBER
31604

SHIPPED VIA

EAGLE PRINTING INK CO.,
83-87 GRAND ST., NEW YORK.

Sold to

DATE Sept. 12, '19

C R & H H Hatch,
ADDRESS 417 Deadrick St.,
Nashville, Tenn.

TERMS 30 DAYS 2% 10 DAYS
SALESMAN Kelly

			Price		
8/26	208 lbs.	Poster Red 16972 A.	.24	49	92

P RR Paid Filled from Factory.
P RR Paid Filled from Factory.

Duplicate.

Invoice Book

Bottom right — Johnson-Wikle Company

JOHNSON-WIKLE COMPANY No. 4861
SUPERIOR PRINTERS ROLLERS
109 S. Forsyth St. ATLANTA, GA. Phone Main 4542

Sold to C R & H H Hatch
Nashville, Tenn

Date Oct. 25. 1917

Terms: Cash, payable 10th. of month following date of invoice.

Shop No. 791

Quantity	DESCRIPTION	Weight	Total Weight	Price	Amount	Total
2	Form Rollers for Whitlock	12	24	40	9 60	
4	Dist. " "	6½	26	40	10 40	
2	Fount " "	6½	13	40	5 20	
2	Form " " Pony Whitlock	8	16	40	6 40	
4	Dist. " "			3.00	12 00	
1	Fount " "				3 00	
4	14½x22 Gordon Rollers			2 40	9 60	
3	10 x 15			1 50	4 50	
					60 70	
	Less Special Disct. on Job Rollers				4 50	56 20

2% 10 days. 30 days Net.

We hereby guarantee that the goods listed herein were produced in accordance with the Federal Child Labor Act of Sept. 1st, 1916. JOHNSON-WIKLE CO.

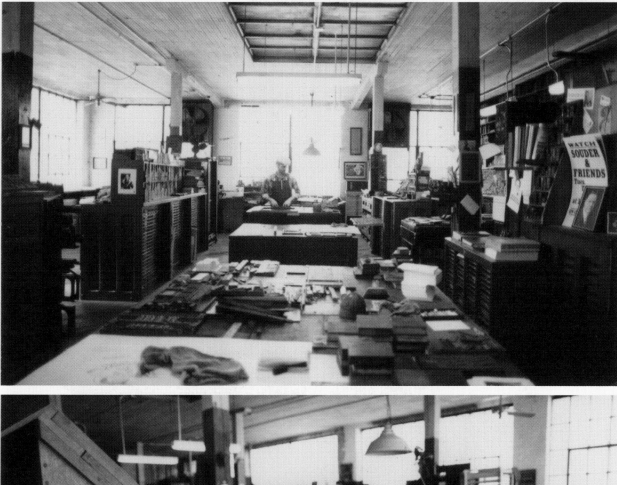

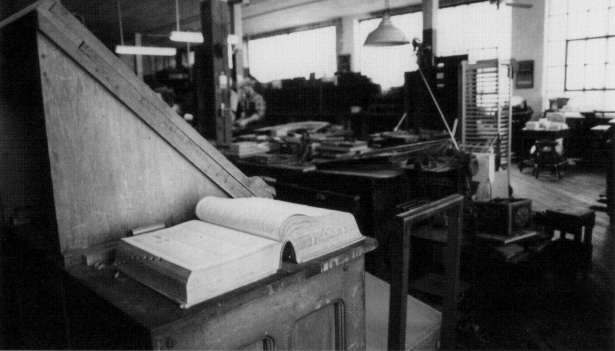

On January 1, 1924, Hatch Show Print opened its newly built printing plant on Fourth Avenue North. Proprietor Will T. Hatch had taken over the business three years earlier from his father, Charles, and uncle, Herbert. Will T., known as Bill, commemorated the new shop's opening by giving each of his employees an Ingersoll watch, bought from Heullebrand Brothers at 312 Union Street.

Nashville's population was close to 120,000, and the Chamber of Commerce boasted about the city's industriousness, with slogans such as, "Nashville Is the South's Life Insurance Center," or, "Nashville Is the South's Great Printing and Publishing Center."

Top left: Interior of the shop,
116 Fourth Avenue North, c. 1984

Left: Dictionary, in the foreground,
at 116 Fourth Avenue North, c. 1984

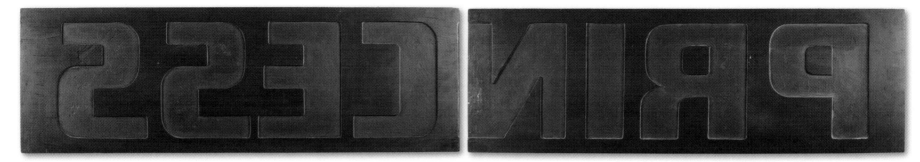

Above: Two forty-by-thirteen-inch wood blocks for Princess Theatres, likely from the 1930s

Will T. Hatch ran the presses himself, printing posters and advertisements for downtown theaters such as the Crescent and the Princess, which showed films featuring cowboy stars like Tom Mix or Bob Steele—who provided inspiration to the Stetson-wearing musical entertainers who would soon order posters from Hatch Show Print for their bands.

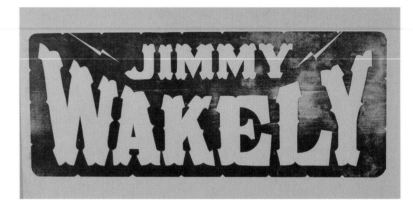

Above: Jimmy Wakely started performing on radio in the late 1930s, and appeared in western movies, usually in support of other leading cowboys, in the 1940s. In addition to recording with Decca and Capitol during his career, he had his own comic book with DC Comics, and was a regular host of *Five Star Jubilee.*

Left: Wood blocks for film stars William S. Hart and Tom Mix. The peak of Hart's career came from 1914 to the early 1920s. Tom Mix rose to prominence soon thereafter.

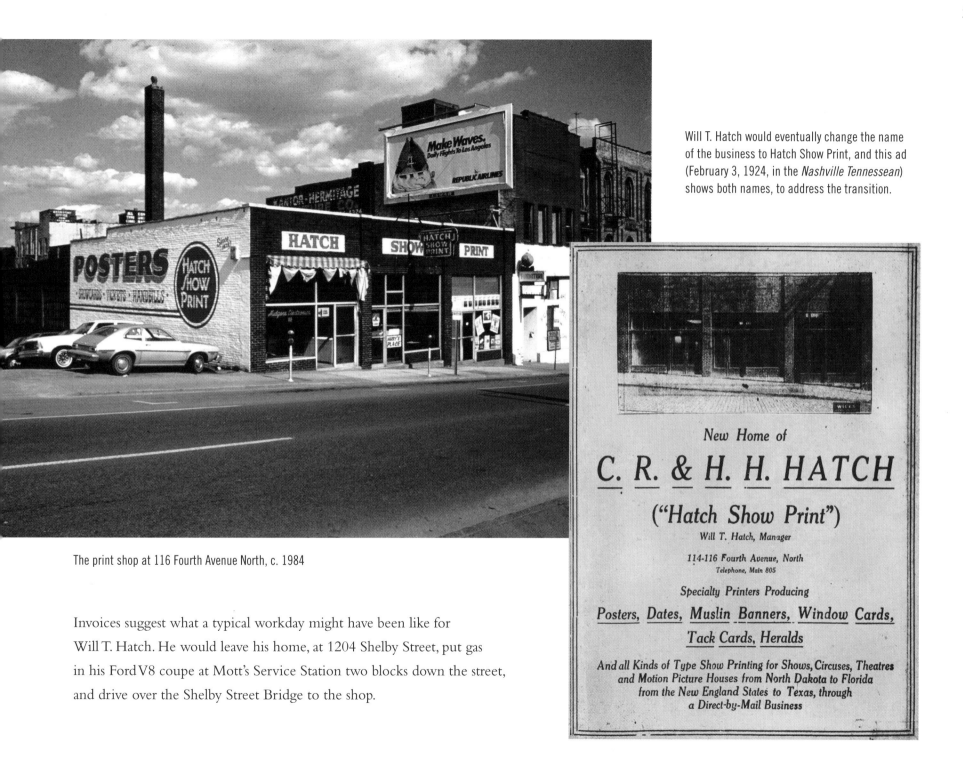

Will T. Hatch would eventually change the name of the business to Hatch Show Print, and this ad (February 3, 1924, in the *Nashville Tennessean*) shows both names, to address the transition.

The print shop at 116 Fourth Avenue North, c. 1984

Invoices suggest what a typical workday might have been like for Will T. Hatch. He would leave his home, at 1204 Shelby Street, put gas in his Ford V8 coupe at Mott's Service Station two blocks down the street, and drive over the Shelby Street Bridge to the shop.

New Home of

C. R. & H. H. HATCH

("Hatch Show Print")

Will T. Hatch, Manager

114-116 Fourth Avenue, North
Telephone, Main 805

Specialty Printers Producing

Posters, Dates, Muslin Banners, Window Cards, Tack Cards, Heralds

And all Kinds of Type Show Printing for Shows, Circuses, Theatres and Motion Picture Houses from North Dakota to Florida from the New England States to Texas, through a Direct-by-Mail Business

In his office, Hatch designed posters from sketches and clip art kept in a locked, fireproof cabinet purchased for ninety-four dollars from the Safe Cabinet Company in Ohio. He ordered paper from the Graham Paper Company in yellow, cherry, pink, orange, eggshell, canary blue, green, and buff.

He bought ink from Sinclair and Lewis, or might have walked across the street to Lewis-Roberts Ink at 115 Fourth Avenue North, if he needed a special color in a hurry. Photoplates were etched locally at Dixie Electrotype Company, Inc. or Capitol Engraving Company. Wood blocks from Thompson Cabinet Company in Michigan were ordered sixty to one hundred at a time and delivered by Universal Car in crates weighing up to 800 pounds.

Washington Transfer delivered more wood blocks and drying racks, and the typesetting for smaller jobs—of letterheads, pamphlets, and business cards—was outsourced to E.T. Lowe, paid for by the pound. Paper clips were ordered, 25,000 at a time. During the Christmas holidays, Hatch's staff—John Boyd, A. A. Thompson, William B. Deaderick, Wiley Irving, Billy Lawrence, C. A. Smith, and Pearl Ravis—each received a bonus of five dollars.

Left: Hatch Show Print relied on a variety of vendors: E. T. Lowe provided linotype typesetting services; Capitol Engraving made photoplates; and Thompson Cabinet Company filled regular orders for type-high basswood poster boards, which the shop's staff carved into poster artwork.

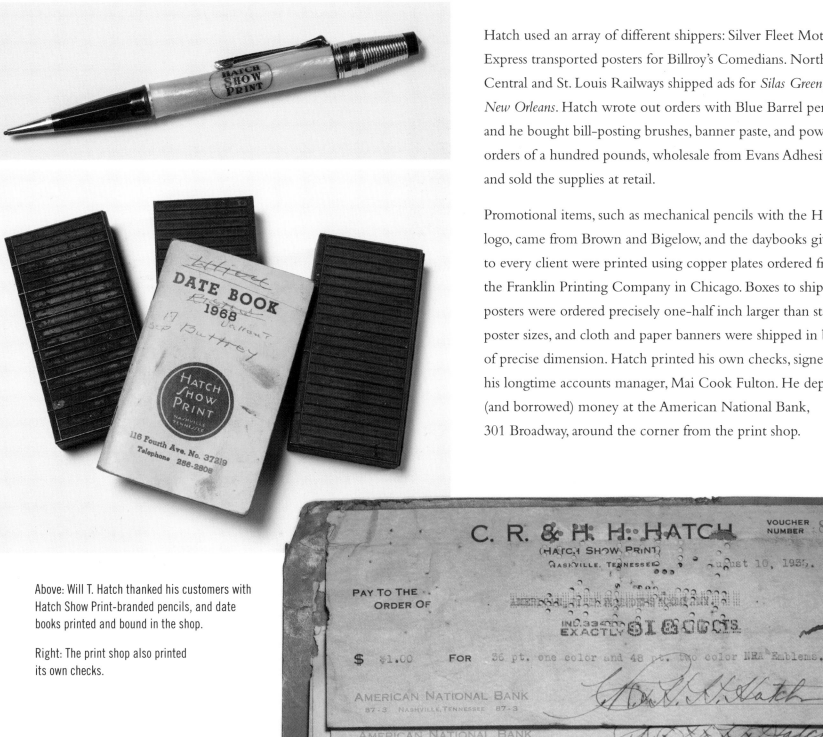

Hatch used an array of different shippers: Silver Fleet Motor Express transported posters for Billroy's Comedians. Northern Central and St. Louis Railways shipped ads for *Silas Green from New Orleans*. Hatch wrote out orders with Blue Barrel pencils, and he bought bill-posting brushes, banner paste, and powder in orders of a hundred pounds, wholesale from Evans Adhesives, and sold the supplies at retail.

Promotional items, such as mechanical pencils with the Hatch logo, came from Brown and Bigelow, and the daybooks given to every client were printed using copper plates ordered from the Franklin Printing Company in Chicago. Boxes to ship posters were ordered precisely one-half inch larger than standard poster sizes, and cloth and paper banners were shipped in boxes of precise dimension. Hatch printed his own checks, signed by his longtime accounts manager, Mai Cook Fulton. He deposited (and borrowed) money at the American National Bank, 301 Broadway, around the corner from the print shop.

Above: Will T. Hatch thanked his customers with Hatch Show Print-branded pencils, and date books printed and bound in the shop.

Right: The print shop also printed its own checks.

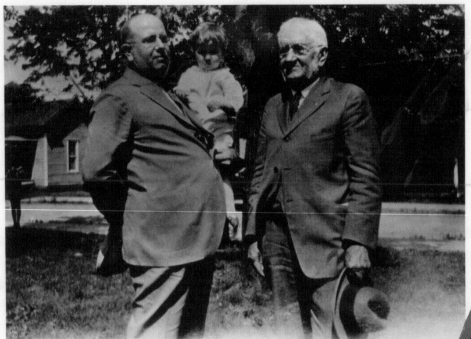

In the evening, after he and his wife, Allene, put Will Jr. and daughter Mary to bed, Will T. would draw on wood blocks at the kitchen table. If the workload got too heavy, he would commission help from local designers such as Ernest Pickup, Clyde Clack, or Keith-Simmons National Printing and Engraving.

Above: Will T. Hatch, Will T. Junior, and Will T.'s uncle, William H. Hatch, c. 1926

Right: Will T. Hatch's telephone list, called "Bates Index," includes early telephone numbers for Bill Monroe, Pee Wee King, Ryman Auditorium manager Lula Naff, and others.

Above: Before committing a sketch to a set of blocks for carving, Will T. Hatch might paint an egg tempura mock-up, like this one for Pee Wee King's band, the Golden West Cowboys.

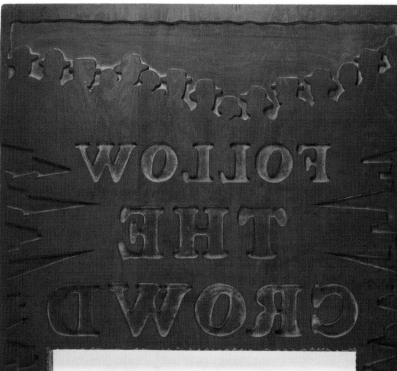

Walking through the print shop today, it's hard to imagine that the collection of wood blocks represents only ten percent of what was ever carved at, or for, Hatch Show Print. For example, while this "Follow the Crowd" wood block still exists, gone are the blocks cut the same day, in April 1934, reading "It Won't Be Long," and "Only a Few Days."

Top: Hand-carved blocks, many dating to the shop's beginnings.

Above: Wood type and image blocks.

"Follow the Crowd" one-sheet wood block, c. 1934. The open or "mortised" area could be typeset with copy to be printed in the same color as the block.

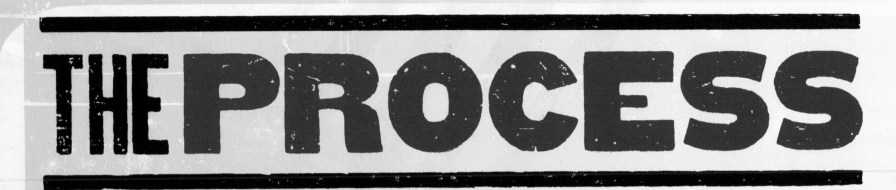

THE PROCESS

1) To create a print block, Will T. Hatch started with a source of inspiration such as this engraving of George Washington. 2) In this illustration, Will T. used bold lines to define Washington's features. 3) The image was simplified further to achieve the proper balance of positive and negative space.

1

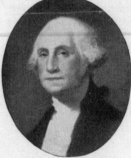

GEORGE WASHINGTON
Born in Virginia, Feb. 22, 1732
President from 1789 to 1797
Died Dec. 14, 1799
Brown's Pictures—Miniature—1

2

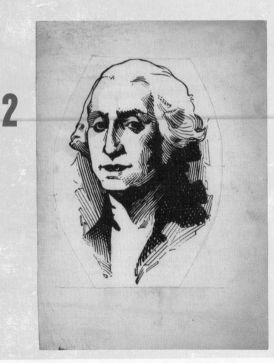

3

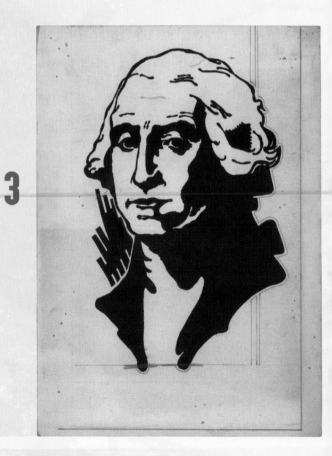

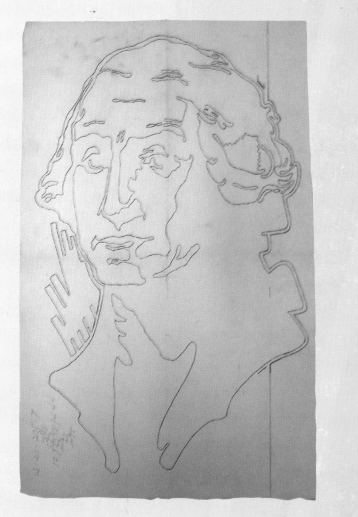

4

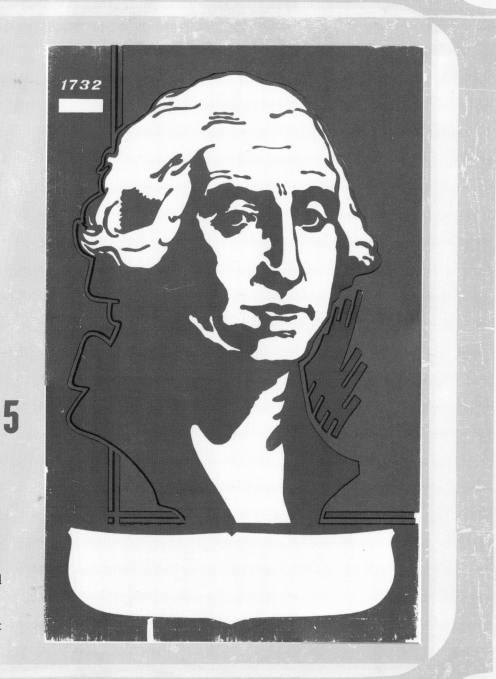

5

4) This pencil drawing with outlines of the image was transferred to two blocks to create a two-color poster. Additional graphic elements were sketched onto the wood blocks, and the wood not meant to be printed was carved away. 5) The final print, c. 1940.

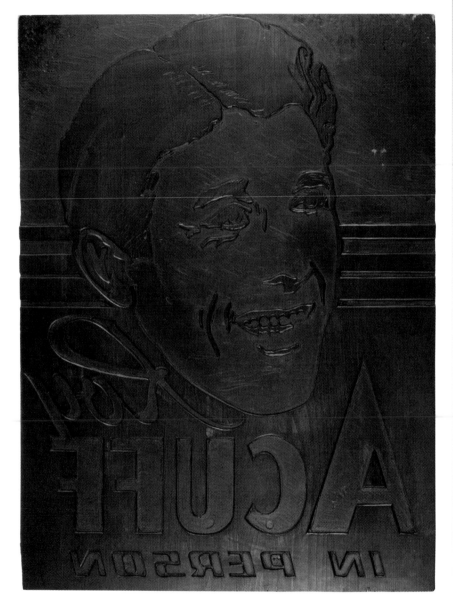

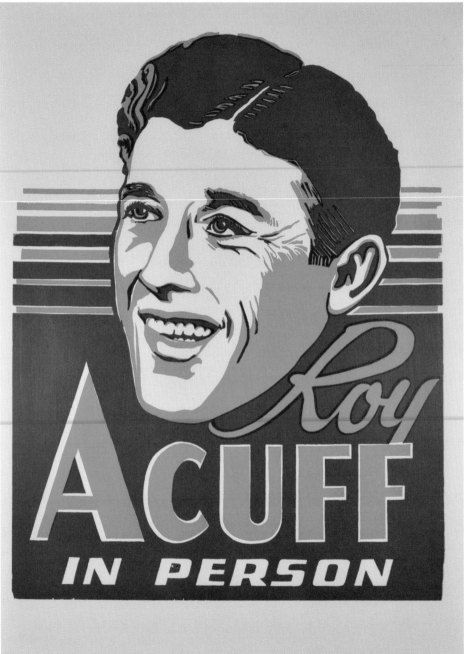

One-sheet wood block, carved in 1939 or 1940 as the second color of a two-color poster. A restrike of the complete poster can be seen on the right.

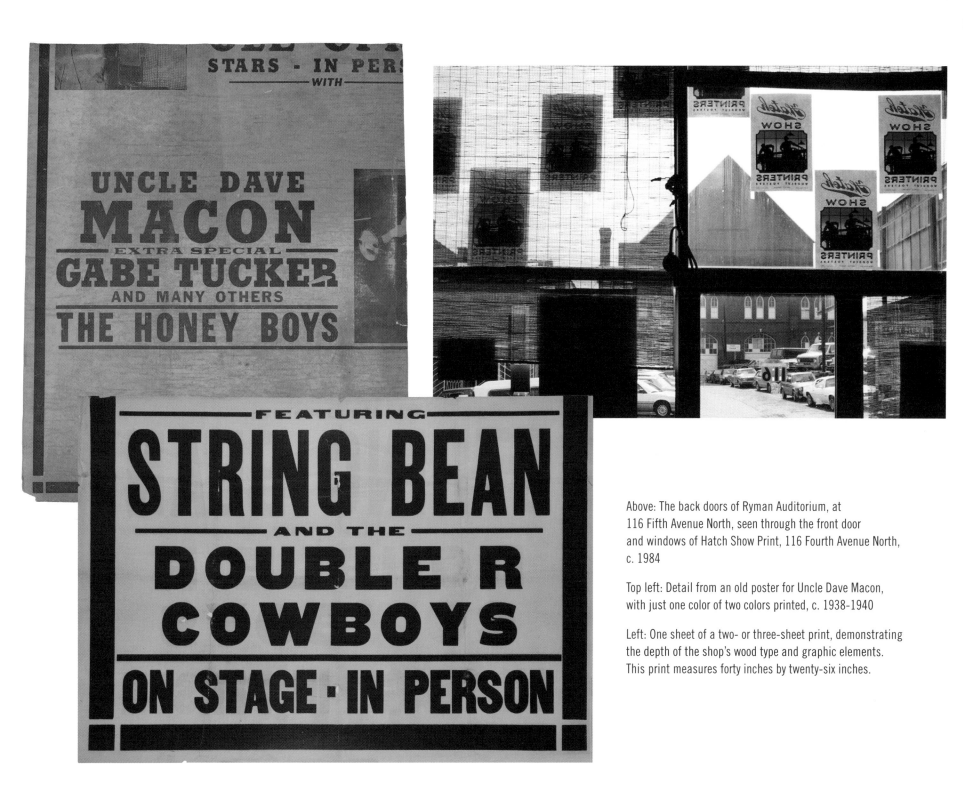

Above: The back doors of Ryman Auditorium, at 116 Fifth Avenue North, seen through the front door and windows of Hatch Show Print, 116 Fourth Avenue North, c. 1984

Top left: Detail from an old poster for Uncle Dave Macon, with just one color of two colors printed, c. 1938-1940

Left: One sheet of a two- or three-sheet print, demonstrating the depth of the shop's wood type and graphic elements. This print measures forty inches by twenty-six inches.

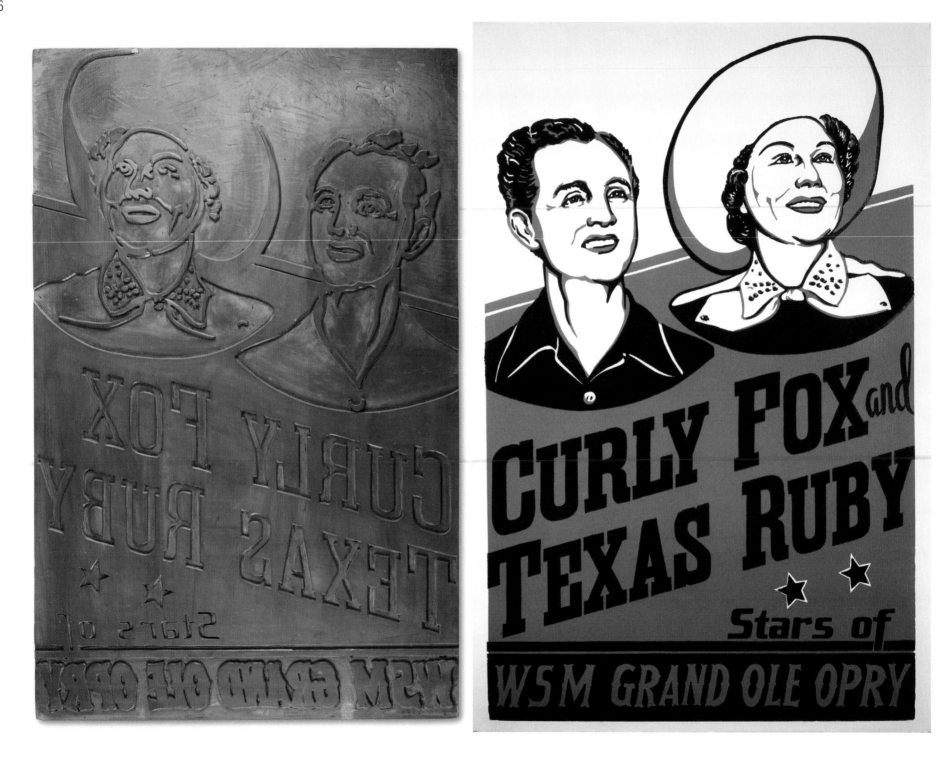

Left: One-sheet wood block, c. 1940s,
for Nashville-area radio station 1430 AM WENO,
a prominent supporter of country music

Opposite: One-sheet wood block, carved in
1939 or 1940 as the first color of a two-color poster.
To its right, a restrike of the complete poster.

Right: Wood block, c. 1940s, most likely produced
for *Renfro Valley Barn Dance* (among the many barn
dance radio shows the shop designed and produced
advertisements for in the 1940s and 1950s)

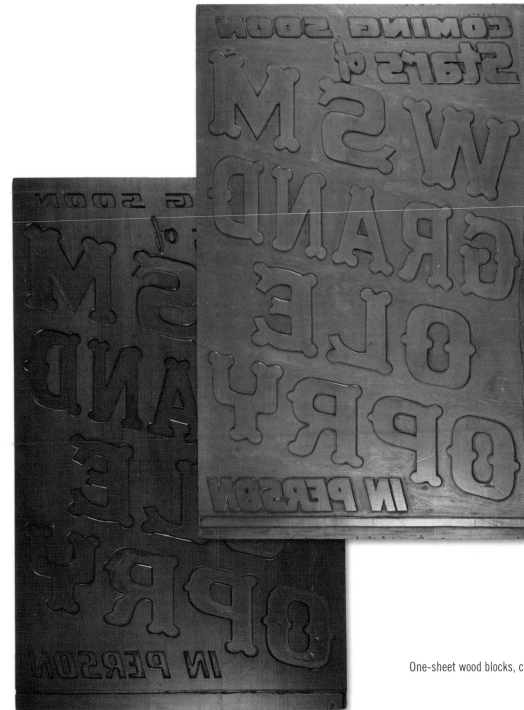

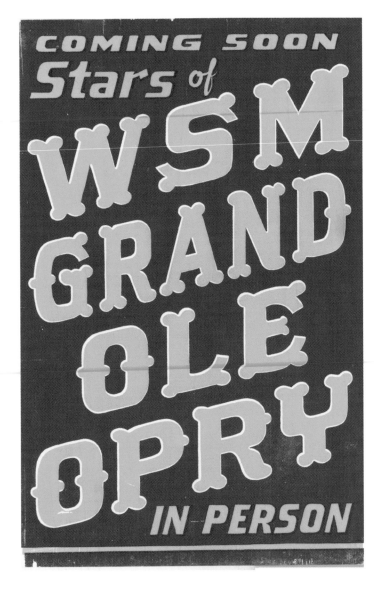

One-sheet wood blocks, carved in 1939 or 1940, and a restrike of the blocks

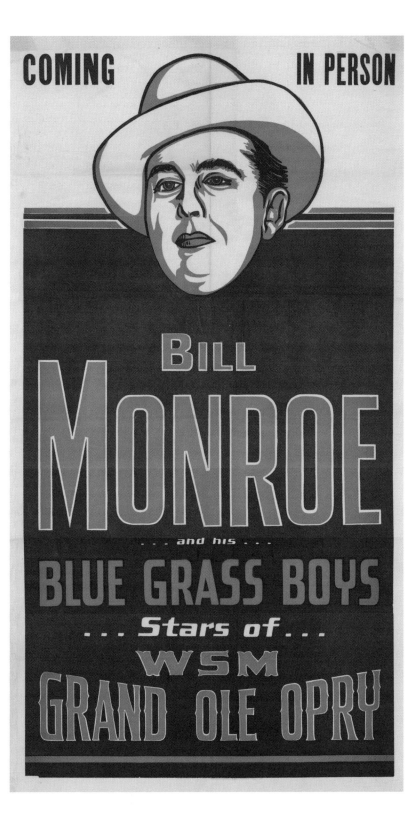

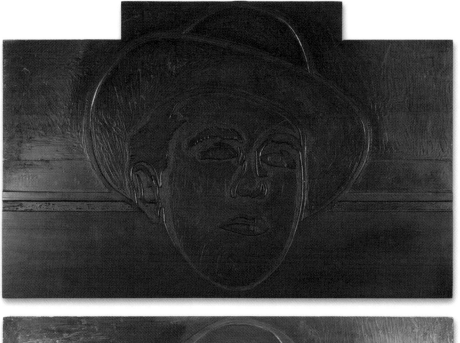

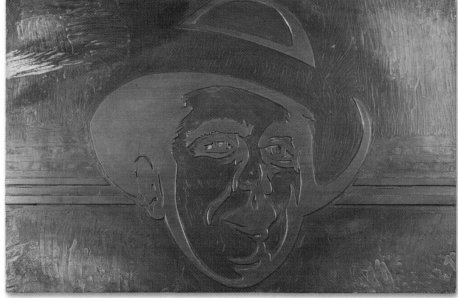

One-sheet wood blocks, carved in 1939 or 1940, that make up the top third of a three-sheet poster for Bill Monroe. The cuts made into the top of the blue block allowed printers to typeset and add the words "Coming In Person," as the poster was produced.

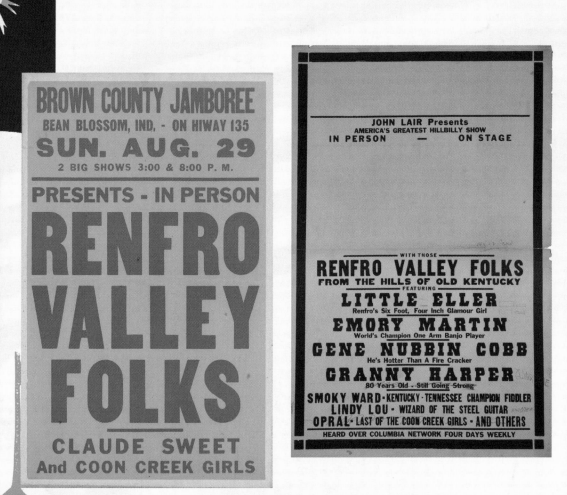

BROWN COUNTY JAMBOREE
BEAN BLOSSOM, IND. - ON HIWAY 135
SUN. AUG. 29
2 BIG SHOWS 3:00 & 8:00 P.M.
PRESENTS - IN PERSON
RENFRO VALLEY FOLKS
CLAUDE SWEET
And COON CREEK GIRLS

JOHN LAIR Presents
AMERICA'S GREATEST HILLBILLY SHOW
IN PERSON — ON STAGE

WITH THOSE
RENFRO VALLEY FOLKS
FROM THE HILLS OF OLD KENTUCKY
FEATURING
LITTLE ELLER
Renfro's Six Foot, Four Inch Glamour Girl
EMORY MARTIN
World's Champion One Arm Banjo Player
GENE NUBBIN COBB
He's Hotter Than A Fire Cracker
GRANNY HARPER
80 Years Old - Still Going Strong
SMOKY WARD - KENTUCKY - TENNESSEE CHAMPION FIDDLER
LINDY LOU - WIZARD OF THE STEEL GUITAR
OPRAL - LAST OF THE COON CREEK GIRLS - AND OTHERS
HEARD OVER COLUMBIA NETWORK FOUR DAYS WEEKLY

Left: Posters advertising the stars of the *Renfro Valley Barn Dance* on tour, c. 1954 (far left) and 1946. The black print shows the start of a two-color poster; the second color may have included a photoplate, wood block, or the name of the headliner.

Below: A c. 1949 poster for the Bailes Brothers, Johnnie and Homer, who were early performers on the *Louisiana Hayride* radio show

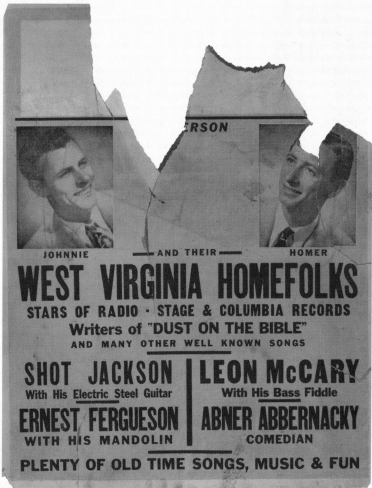

JOHNNIE — AND THEIR — HOMER
WEST VIRGINIA HOMEFOLKS
STARS OF RADIO · STAGE & COLUMBIA RECORDS
Writers of "DUST ON THE BIBLE"
AND MANY OTHER WELL KNOWN SONGS
SHOT JACKSON
With His Electric Steel Guitar
LEON McCARY
With His Bass Fiddle
ERNEST FERGUESON
WITH HIS MANDOLIN
ABNER ABBERNACKY
COMEDIAN
PLENTY OF OLD TIME SONGS, MUSIC & FUN

The NBC radio network began broadcasting the Grand Ole Opry nationwide for a half hour on Saturday night in 1939, and posters were needed to showcase road tours of the magical voices now heard by so many. Posters for the clients of promoter J. L. Frank, or WSM's tobacco-sponsored *Camel Caravan*, were designed by the staff at Hatch Show Print, often with a likeness of the entertainer carved into the wood block. Minnie Pearl once said, aptly, "All you needed was a Hatch poster to let you know the Opry was coming to town."

Radio barn dances—essentially variety shows featuring music and comedy on a stage, in front of a live audience, carried live on the radio—became a popular and prevalent entertainment form after Chicago's *National Barn Dance*, Dallas's *Big D Jamboree*, and Nashville's Grand Ole Opry led the way in the 1920s.

continued on page 47

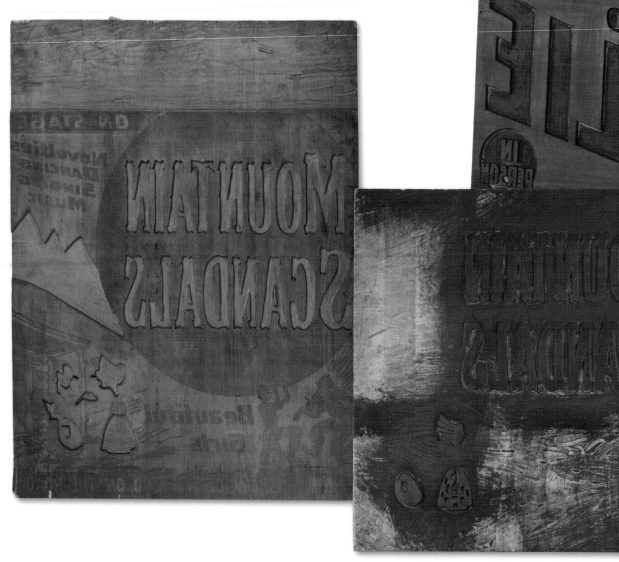

Above: Half-sheet block for Sarie and Sallie, a sister comedy act that appeared on the Grand Ole Opry from 1934 to 1939

Left: Two half-sheet blocks for a three-color poster advertising *Mountain Scandals*, a live variety show that toured in the mid-1940s

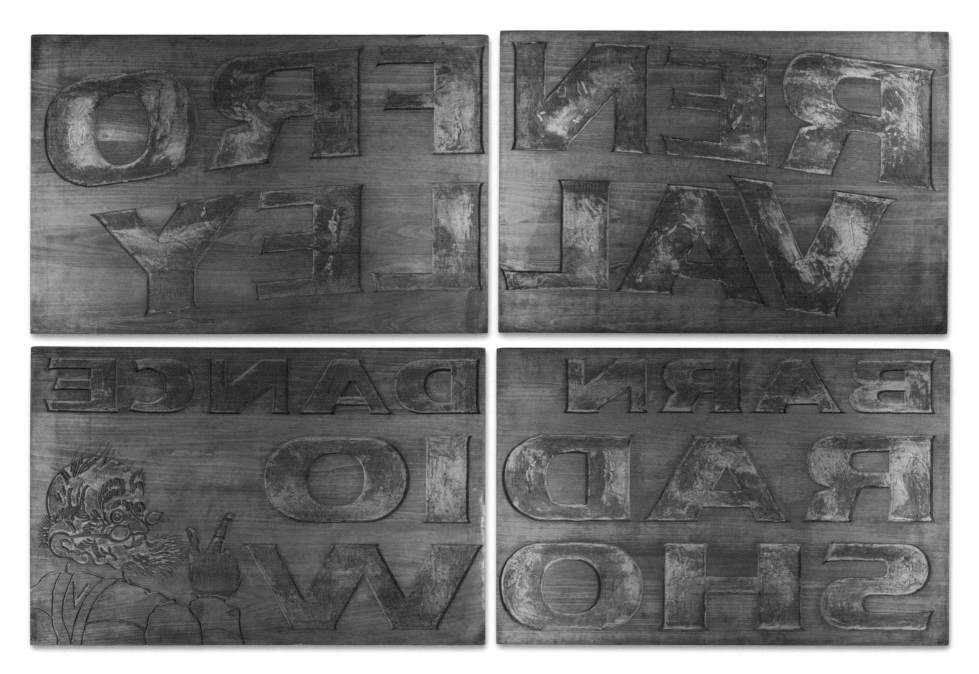

These four blocks made up a four-sheet poster for the *Renfro Valley Barn Dance* radio show, c. 1940s.

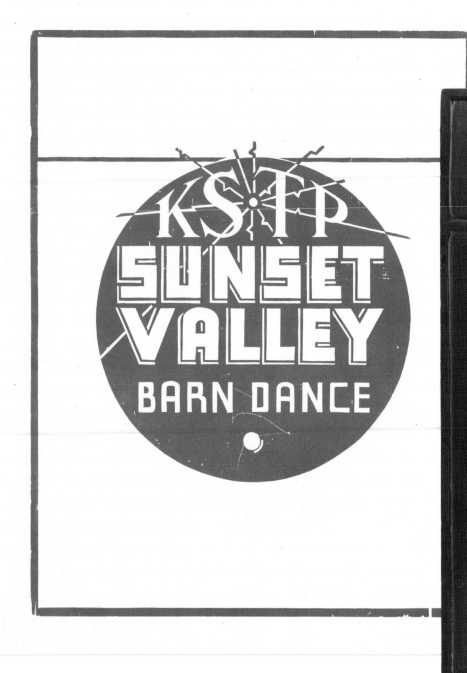

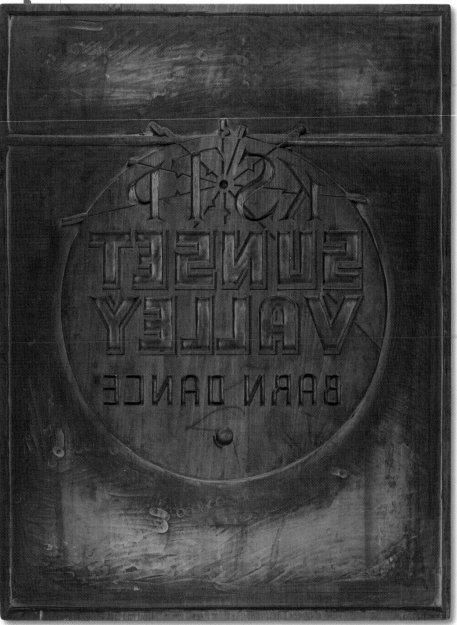

Restrike and one block of a two-color, one-sheet poster for KSTP's *Sunset Valley Barn Dance*, c. 1940

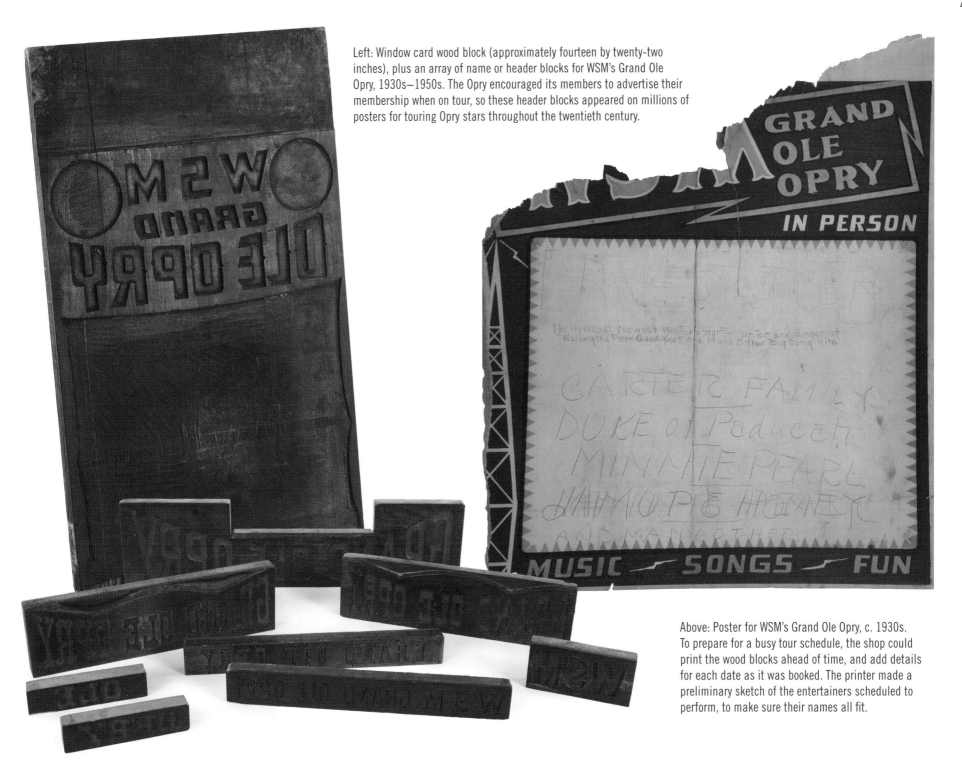

Left: Window card wood block (approximately fourteen by twenty-two inches), plus an array of name or header blocks for WSM's Grand Ole Opry, 1930s–1950s. The Opry encouraged its members to advertise their membership when on tour, so these header blocks appeared on millions of posters for touring Opry stars throughout the twentieth century.

Above: Poster for WSM's Grand Ole Opry, c. 1930s. To prepare for a busy tour schedule, the shop could print the wood blocks ahead of time, and add details for each date as it was booked. The printer made a preliminary sketch of the entertainers scheduled to perform, to make sure their names all fit.

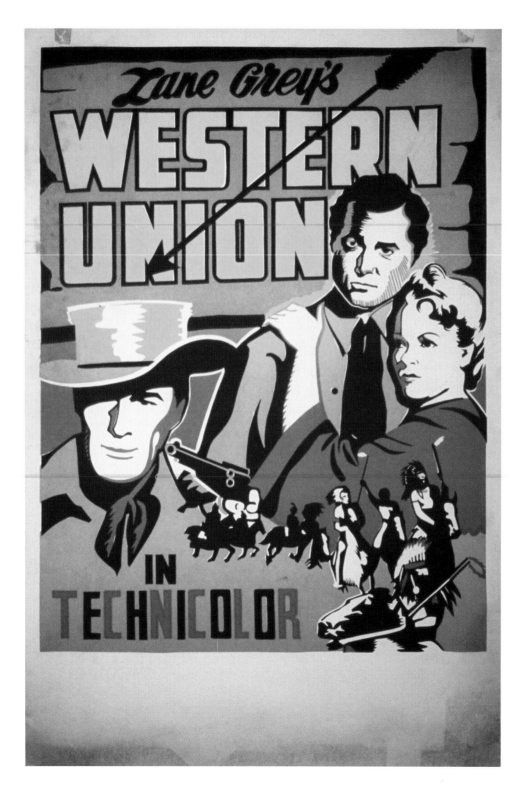

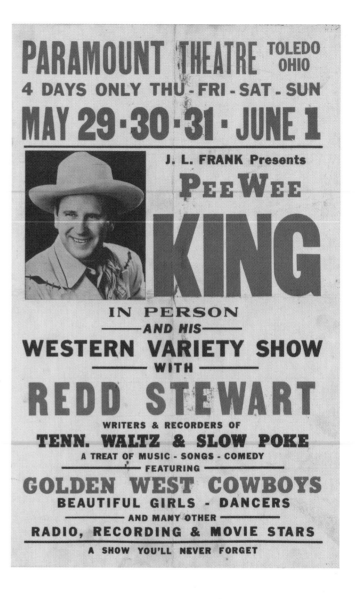

Above: Poster for Pee Wee King, who recorded "Tennessee Waltz" in 1947. After joining the Grand Ole Opry in 1937, King appeared in movies, including one with Gene Autry.

Left: Poster for *Western Union* (1941). This film does not feature singing cowboys, but appealed to audiences attracted to western themes.

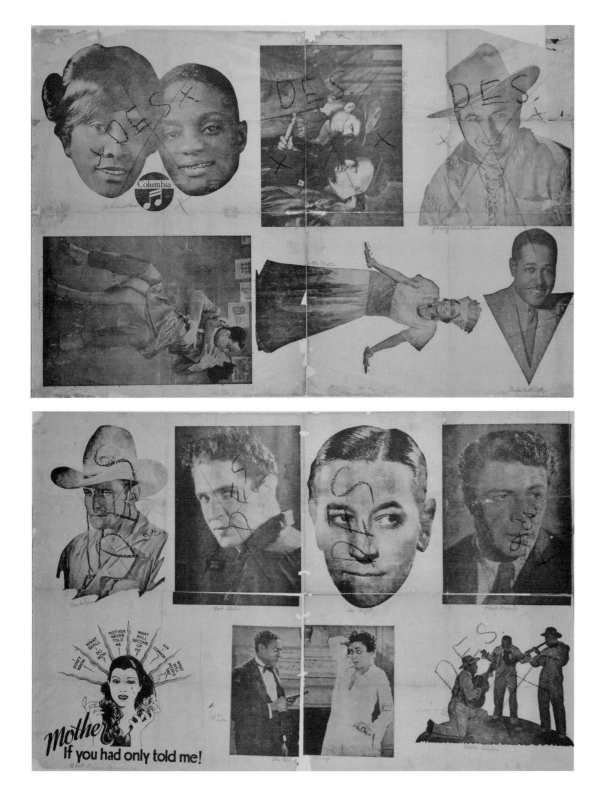

continued from page 42

Clients who bought advertising on the barn dance radio shows were often also buying promotional posters from Hatch Show Print. In July 1940, the Opry ordered 300 jumbo cards and 16,000 attendance cards. In August 1943, they ordered "NO SMOKING" cards for their new home at Ryman Auditorium, and a run of three-sheet advertisements, entered as "Special 3 Sheet Posters... Every Sat. Nite 6 PM."

Hatch Show Print did not escape the impact of World War II. Paper and ink were available, but metal alloys were a premium material, and orders for printing presses and paper cutters were delayed until after the war. Only in 1947 did the shop receive its new, 9,360-pound paper cutter. To contribute to the war effort, most print shops responded to the government's request for metal. In March 1943, the shop returned approximately 550 pounds of lead to American Type Founders, for melting. Those requests prompted Will T.'s nephew and head pressman, Charlie Shelton, to write letters to customers requesting direction on future work, or permission to destroy existing photo plates.

Proof sheets showing photoplates made in the early twentieth century, many of which were destroyed during World War II, so the metal could be recycled and reused. Actor Johnny Mack Brown (top row, right) appeared in Western movies for over forty years; Buck Jones (top row of second sheet, left), was a real-life cowboy turned movie star.

BILL MONROE

Bill Monroe's (1911-1996) title as "The Father of Bluegrass" aptly describes his status as the founder of carefully arranged, harmony-rich stringband music laced with blues and gospel influences. A powerful mandolin player, Monroe sang in a tight-throated tenor that defined the genre's high, lonesome sound.

Born near Rosine, Kentucky, Monroe was the youngest child in a musical family. After his parents died, he followed his brothers to Chicago and performed with them on local radio.

When Bill and his guitar-playing brother Charlie moved to North Carolina, their radio fame led to a recording contract. The brothers split in 1938, and Bill formed a new band called the Blue Grass Boys. The act secured a Grand Ole Opry slot in 1939, and developed a distinctive sound.

Hatch Show Print still sells historic restrikes of posters the shop made for Monroe decades earlier. The hand-carved wood block depicting Monroe's face remains one of the print shop's most recognizable images.

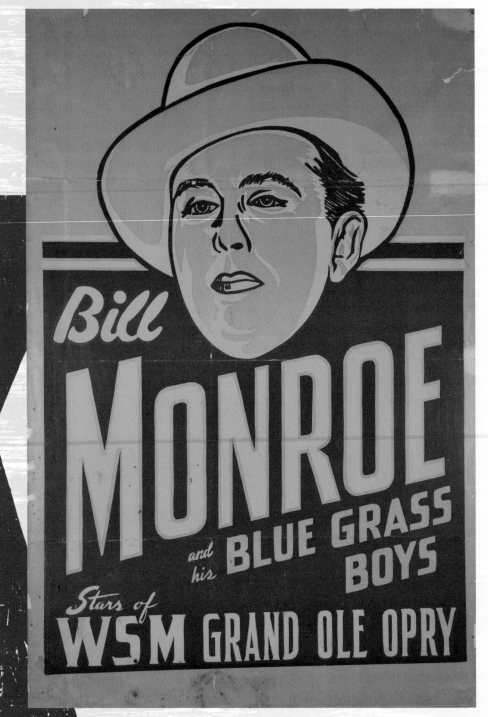

c. 1940s

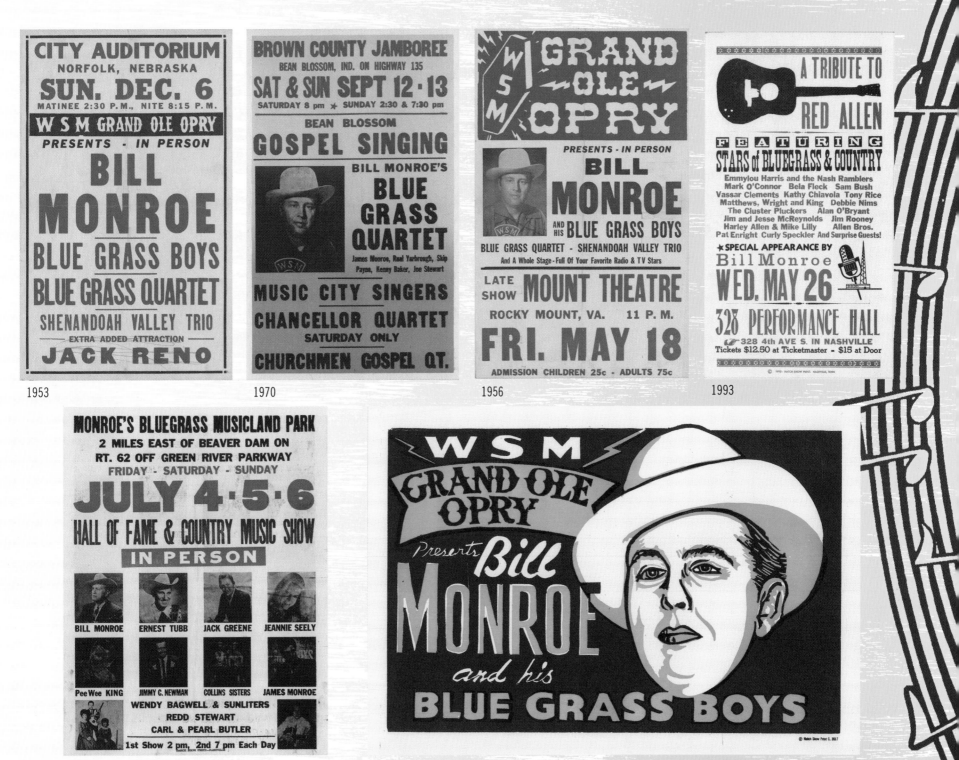

1953

1970

1956

1993

1975

Restrike of a c. 1940s poster

ELECT

ROY ACUFF GOVERNOR TUESDAY NOV 2

So famous was Roy Acuff in the 1940s, that he was persuaded to run for governor of Tennessee twice, in 1944 and 1948. Hatch Show Print printed posters for Acuff when he toured as an entertainer, and the shop got the contract for his campaign posters. Acuff had another connection to Hatch Show Print. His campaign manager, Stanley Fulton, was married to the shop's bookkeeper, Mai Cook Fulton. With the profit from an order of 10,000 posters, Will T. bought a new neon sign from Balton and Cummings for $337.50 in 1948. The new sign took care of the building's exterior, and the $211 purchase of a brand new Coke machine, with its own water fountain, took care of the workers inside.

Left: Restrike of Roy Acuff's poster for the 1948 gubernatorial campaign (Tennessee)

Below, left to right: The neon sign Will T. Hatch purchased in 1948; the Coca-Cola cooler, purchased the same year for the staff.

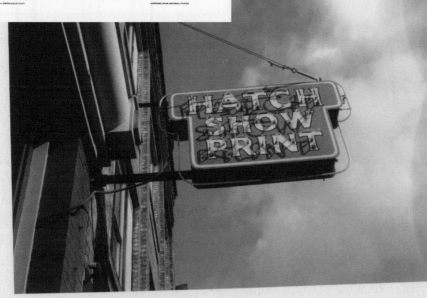

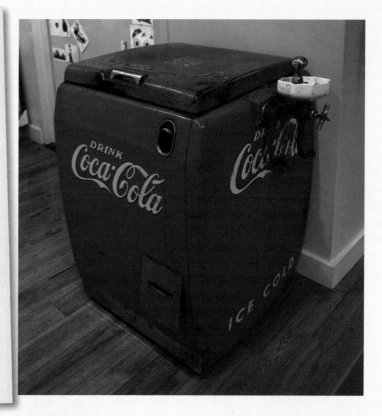

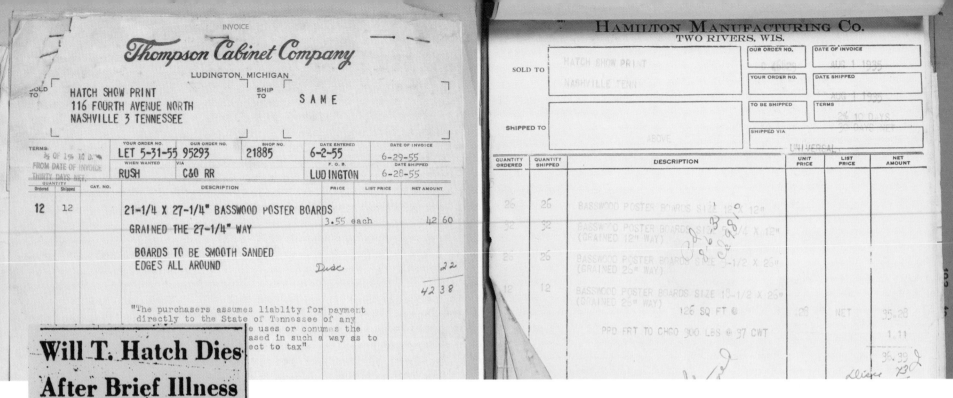

Left: Obituary for Will T. Hatch, dated October 28, 1952

Above: Photo of Hatch

Invoices for purchases of type-high basswood boards from Thompson and wood rule from Hamilton

Acuff's posters were fairly simple, created with a photoplate and hand-set type. They fit the style for political posters of the day. In contrast, most of the work the shop produced at the time used hand-carved wood blocks supported by hand-set wood type to communicate important details. A steady flow of shipments for type-high "poster boards," used to carve the print-ready image blocks, came from Thompson Cabinet Company and Hamilton Wood Type Manufacturing.

While the cost per board foot for poster boards would double by 1954, Will T. Hatch would not live to see it. The print shop owner and visionary died at home on Tuesday, October 28, 1952, three months following a heart attack.

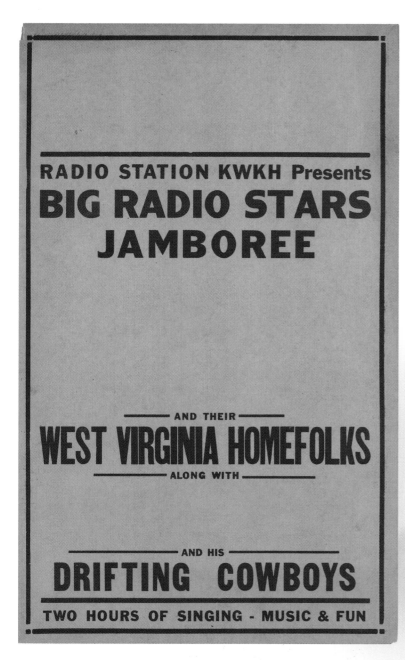

An incomplete half-sheet poster that featured Hank Williams, c. 1948. This poster likely advertised appearances of *Louisiana Hayride* stars.

A month earlier, frequent Hatch Show Print customer Hank Williams recorded "Your Cheatin' Heart," "Kaw-Liga," "Take These Chains from My Heart," and "I Could Never Be Ashamed of You," and was in need of posters for the next ninety days only, though no one could have known that at the time. These posters featured a photograph of the entertainer, produced from an etched copper engraving, a harbinger of the poster aesthetic of the future.

Copper photoplate of Hank Williams

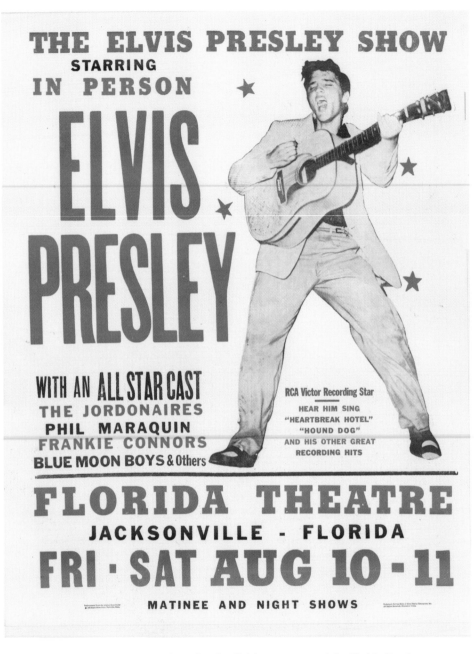

THE ELVIS PRESLEY SHOW
STARRING
IN PERSON
ELVIS PRESLEY

WITH AN ALL STAR CAST
THE JORDONAIRES
PHIL MARAQUIN
FRANKIE CONNORS
BLUE MOON BOYS & Others

RCA Victor Recording Star
HEAR HIM SING
"HEARTBREAK HOTEL"
"HOUND DOG"
AND HIS OTHER GREAT
RECORDING HITS

FLORIDA THEATRE
JACKSONVILLE - FLORIDA
FRI · SAT AUG 10 · 11
MATINEE AND NIGHT SHOWS

Above: This 1956 poster, printed to advertise Elvis's appearance at the Florida Theatre, is a popular restrike.

Right: The large photoplate used to make the poster

Will T. Hatch never witnessed the complete transition the shop's posters made, from a reliance on wood blocks to a dependence on photoplate imagery. He never knew of Elvis Presley's rise to fame and the era in the mid-1950s, during which Hatch Show Print produced Presley's posters for Colonel Tom Parker. He did not endure the struggles of customer attrition, twenty-five years later, as show promoters began buying ads on radio. In 1952, Hatch Show Print was poised to enjoy two more decades of blistering poster business.

continued on page 58

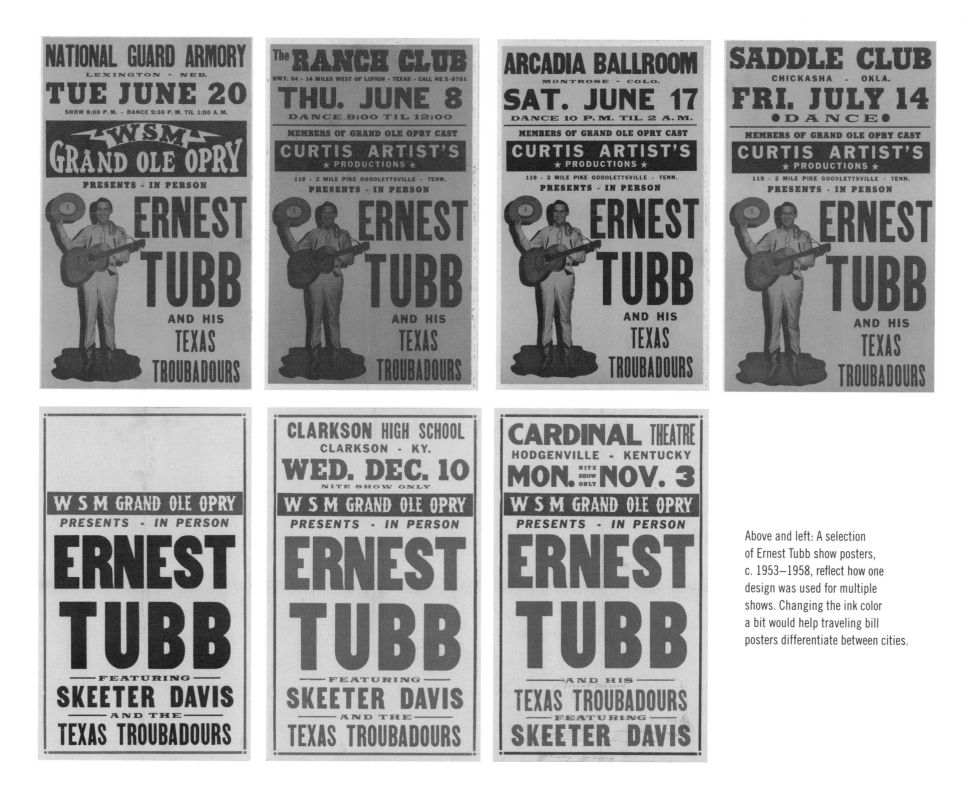

Above and left: A selection of Ernest Tubb show posters, c. 1953–1958, reflect how one design was used for multiple shows. Changing the ink color a bit would help traveling bill posters differentiate between cities.

EDDY ARNOLD

A handsome, smooth singer with refined manners, Eddy Arnold (1918-2008) personified country music's expansion from rural America to the modern, urban world. With chart-making records from 1945 to 2008, he sustained one of the longest careers in American music.

Arnold started performing during the Great Depression to supplement the income of his sharecropping family. He signed with RCA Records in 1943. He dominated country charts for a decade with strong-selling numbers like "That's How Much I Love You" and the million-selling 1948 hit "Bouquet of Roses."

In 1965, he returned to the pop and country charts with "Make the World Go Away." A major proponent of the elegant Nashville Sound, Arnold was one of the first country artists to enjoy crossover success.

Hatch Show Print printed promotional material for Arnold beginning in 1944, and after his death in 2008, made posters for his memorial at the Ryman Auditorium.

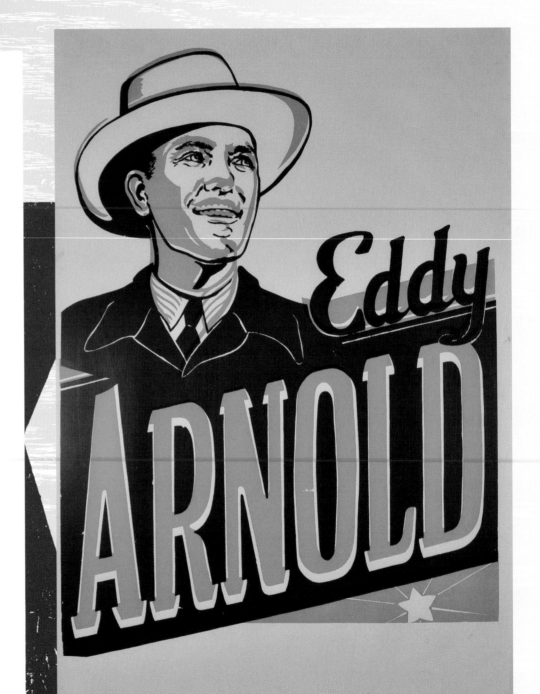

Restrike of a c. 1940s poster

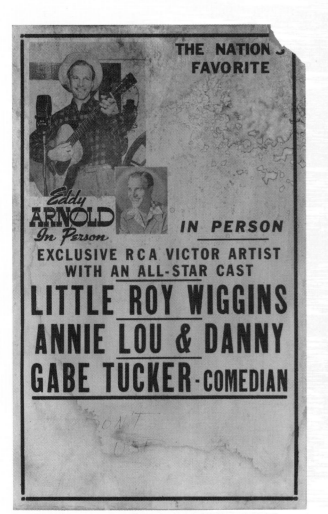

1951

TONIGHT
IN PERSON
EDDY
ARNOLD
TUPELO
FAIRGROUNDS

1957

2006

Below and right: Posters for Kitty Wells (1958); Tommy Sosebee, with Opry radio show founder George D. Hay (1953); Johnny Cash and The Jordanaires (1957); and a package show for Ferlin Husky, featuring his alter ego Simon Crum, along with Opry member-to-be Loretta Lynn (1964). Husky ordered the wood block header pictured below in the 1950s, for his larger posters.

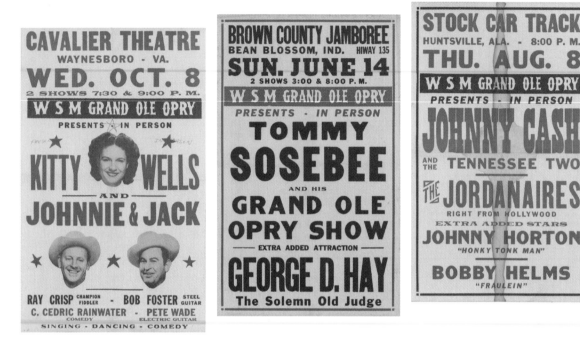

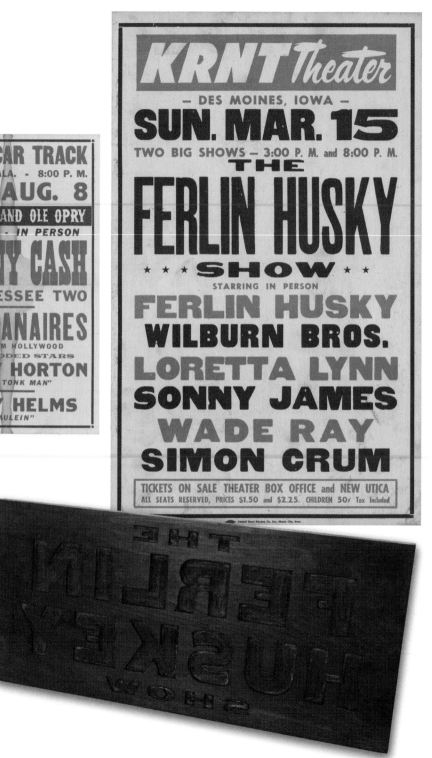

continued from page 54

In the post-war years, it took just a little hustle to participate in the nation's boom economy. Entertainers took to the road more than ever, and they all needed posters. By 1957, the U.S. had over 3,300 radio stations, most AM frequency, with no signs of diminishing growth. In 1964, eleven members of the Grand Ole Opry were dismissed from the Opry for not meeting the show appearance requirement of twenty-six times per year. It was much more lucrative for the entertainers to play out on the road.

continued on page 64

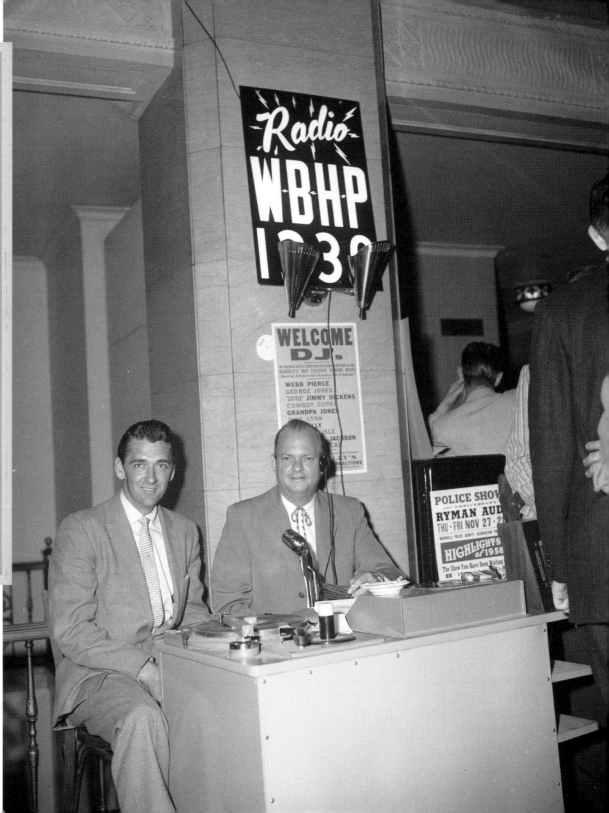

WELCOME DJ's

THE FOLLOWING ARTISTS EXTEND THEIR OPEN HANDS IN INVITATION, TO VISIT
NASHVILLE'S ONLY EXCLUSIVE BOOKING OFFICE
"Booking Artists Is Our Business, Not A Sideline"

WEBB PIERCE
GEORGE JONES
"LITTLE" JIMMY DICKENS
COWBOY COPAS
GRANDPA JONES
JUDY LYNN
PAT KELLY
BILL CARLISLE
STONEWALL JACKSON
LONZO & OSCAR

Our Office Is Open To You At All Times. Come In And Visit, Plenty Of Refreshments

JOHN KELLY'S
WORLD FAMED ATTRACTIONS
319 7TH AVE. NORTH NEXT DOOR TO CLARKSTON HOTEL

Above: For the annual disc jockey convention, Hatch Show Print
made posters touting artists, concert promoters, and booking
agents such as John Kelly, whose roster included five future
members of the Country Music Hall of Fame, c. 1958.

Right: Carl Smith and an unidentified disc jockey (right) for
Huntsville's WBHP, at country music's annual DJ Convention and
Grand Ole Opry Birthday Celebration

Especially during the golden age of the Grand Ole Opry, Hatch Show Print's posters traveled far and wide, from Ontario to Mississippi. From left: Jim Reeves, 1956; Moon Mullican and String Bean, 1956; a Hank Snow package show (including Snow's son, Jimmie), 1957; and a poster layout, used to set the hierarchy of the poster features, with dates and locations to be added later, c. 1960s.

Opposite: The Grand Ole Opry was so popular, showgoers often waited for hours to get in. Here, fans wait in front of a window box containing a three-sheet Hatch Show Print poster, c. 1950s.
Image courtesy of the Grand Ole Opry Archives

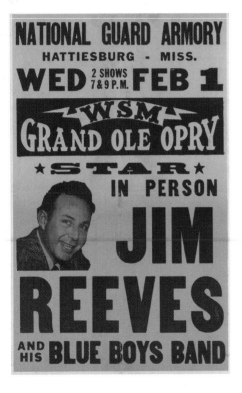

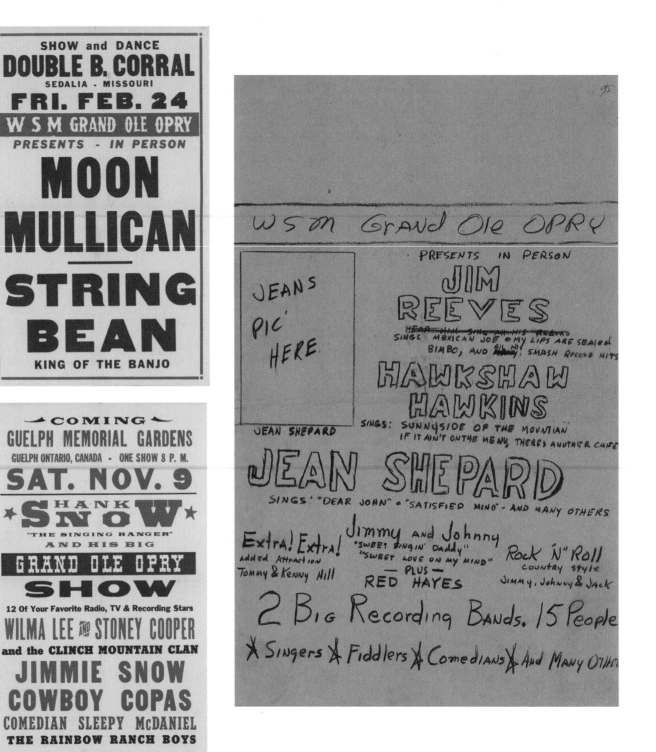

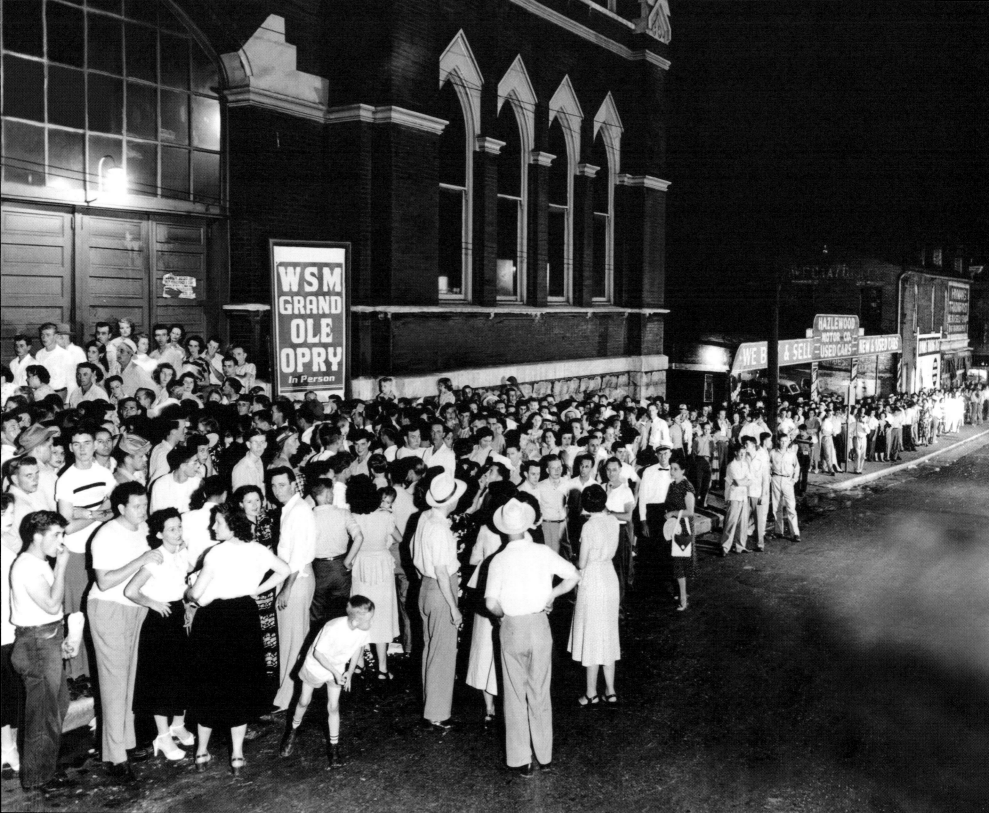

Despite dismissal from the Grand Ole Opry in 1964 because they made too few appearances, these entertainers remained busy in Nashville and on the road.

Faron Young, 1970; Stonewall Jackson, 1970; Kitty Wells, 1976; and a poster advertising upcoming dates at a club, including Faron Young and Ferlin Husky, 1975.

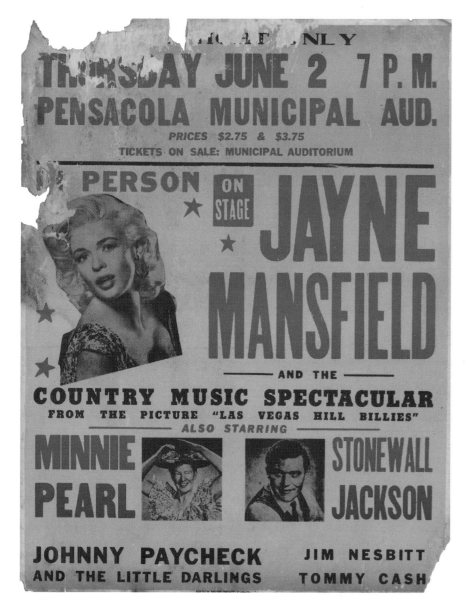

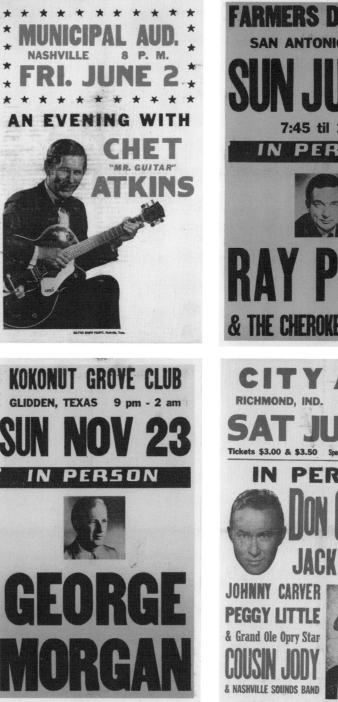

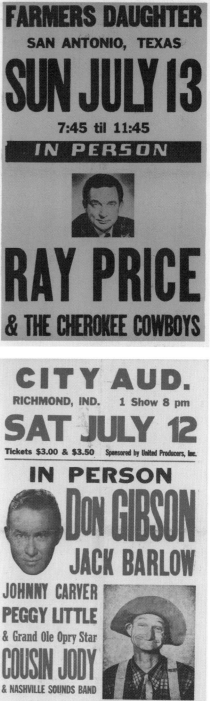

Package shows—like the above featuring actress Jayne Mansfield and Minnie Pearl in 1966—offered diverse entertainment, with comedy, country music, and a little rock & roll. Other posters here show entertainers who continued to work, despite touring without the Grand Ole Opry banner: Chet Atkins, 1972; and Ray Price, George Morgan, and Don Gibson in 1969.

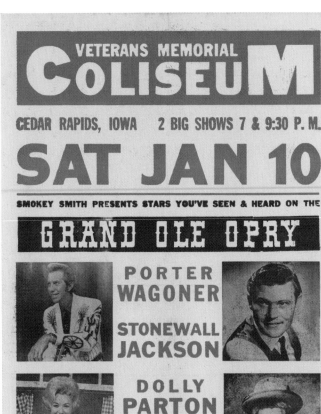

continued from page 58

From May 1964 to May 1965, nearly 2,500 poster jobs were shipped from Hatch Show Print, averaging nine jobs per day, in a five-day work week. Its success and integral role in the music business in Nashville attracted Music Row entrepreneurs Bill Denny and business partner Lucky Moeller, who bought the shop from Will T. Hatch's widow, Allene, in 1964. She had successfully managed the shop with her son following her husband's death. The new owners also made good use of the shop's offset printing press, brought into the business by the Hatch family in the 1950s, to print flyers and brochures.

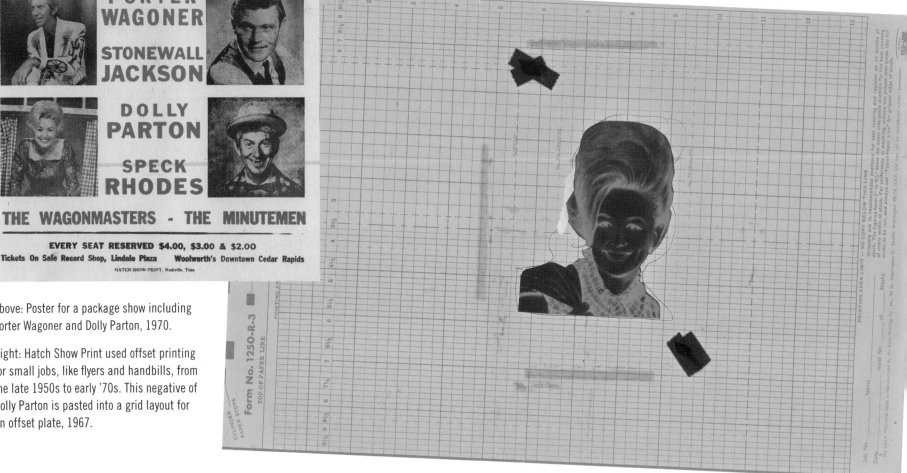

Above: Poster for a package show including Porter Wagoner and Dolly Parton, 1970.

Right: Hatch Show Print used offset printing for small jobs, like flyers and handbills, from the late 1950s to early '70s. This negative of Dolly Parton is pasted into a grid layout for an offset plate, 1967.

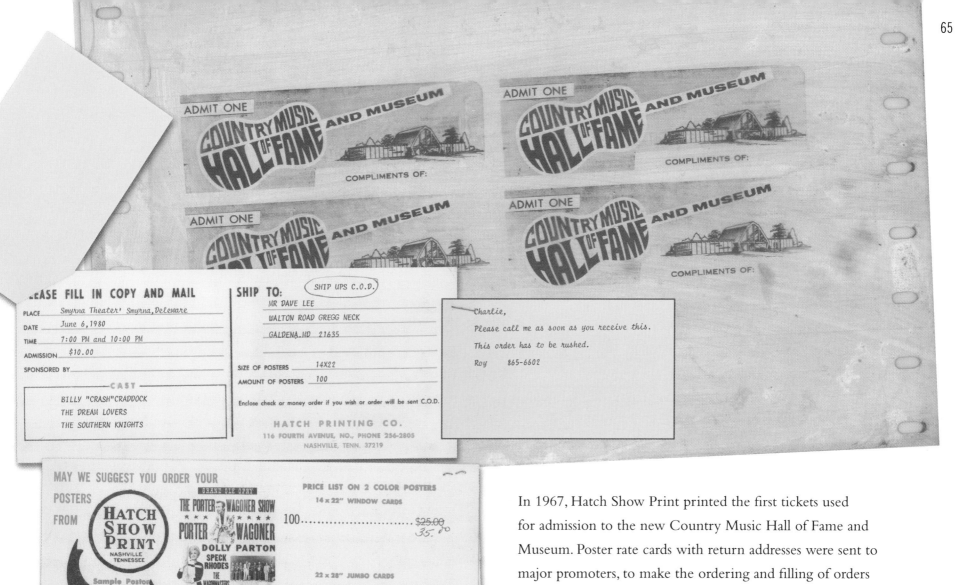

Top: An offset plate used to print the first tickets
for the Country Music Hall of Fame and Museum, 1967

Middle: Order form for concert posters

Bottom: (On the reverse) poster rate card

In 1967, Hatch Show Print printed the first tickets used for admission to the new Country Music Hall of Fame and Museum. Poster rate cards with return addresses were sent to major promoters, to make the ordering and filling of orders easier. Photos, a key design element, had to be approved images. Earl Scruggs, for instance, ordered a new photoplate every six months, from his most recent portrait. Hatch Show Print's gross revenue stuck to a consistent $55,000–$60,000 per year through the mid-1970s, which equates to approximately a quarter million dollars annually, today.

continued on page 70

ROY ACUFF

Roy Acuff's (1903-1992) clear, intensely emotional singing made him one of country music's most popular early stars, and his updated version of rural stringband music made him a pillar of the Grand Ole Opry for half a century.

Acuff learned folk ballads, fiddle tunes, hymns, and pop hits during his youth in Maynardville, Tennessee. When heatstroke ended his major league baseball ambitions, the young performer set his sights on becoming an entertainer.

After five years of struggling, Acuff and his Smoky Mountain Boys snagged a guest spot on the Grand Ole Opry and generated sacks of fan mail with Acuff's rendition of "The Great Speckled Bird."

In recognition of Acuff's broad appeal, baseball great Dizzy Dean gave him the nickname "The King of Country Music," a title Acuff used on some of his Hatch Show Print posters—but not the ones he used when campaigning for governor of Tennessee.

1952

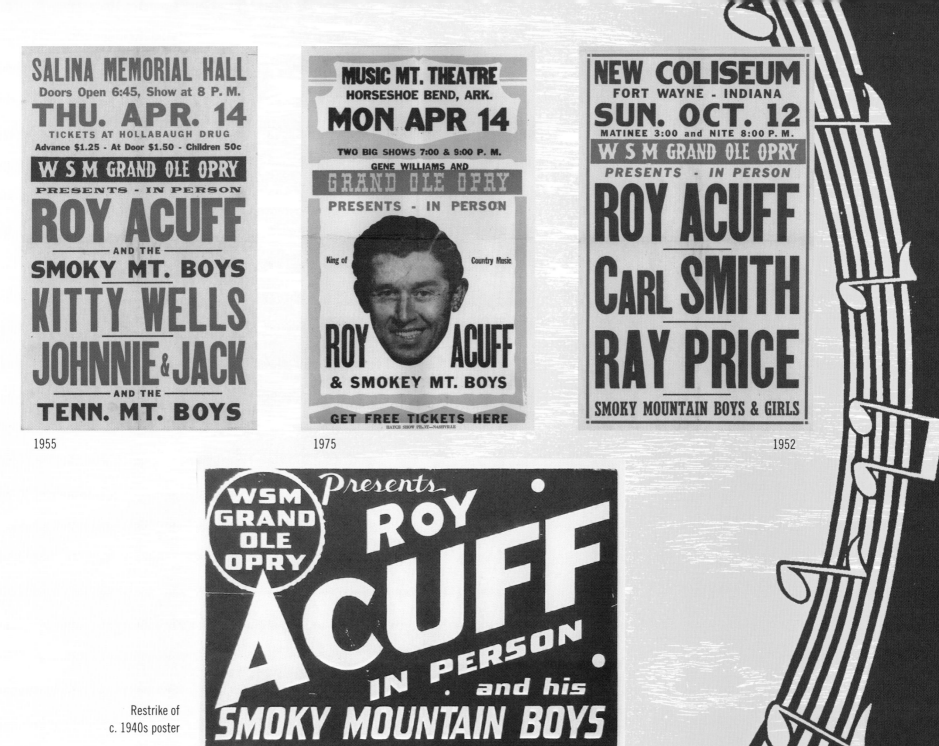

1955

1975

1952

Restrike of
c. 1940s poster

KITTY WELLS

Kitty Wells (1919-2012) was country music's first major female star of the post–World War II era.

A native Nashvillian, she was born Muriel Deason. After marrying Johnnie Wright in 1937, she became the so-called "girl singer" with her husband and Jack Anglin, Wright's partner in the duo Johnnie & Jack. Wright renamed her "Kitty Wells," after a nineteenth-century song.

In 1952, Wells was pondering retirement when she recorded an answer to Hank Thompson's "The Wild Side of Life." Her response, "It Wasn't God Who Made Honky Tonk Angels," spent six weeks atop the country charts.

By proving that women could sell country records, she opened doors for Loretta Lynn and others who followed.

Hatch Show Print made Wells's posters throughout her career, and promoted her 2008 exhibit at the Country Music Hall of Fame and Museum. She is one of the artists featured in the MCA-Country Music Hall of Fame CD series.

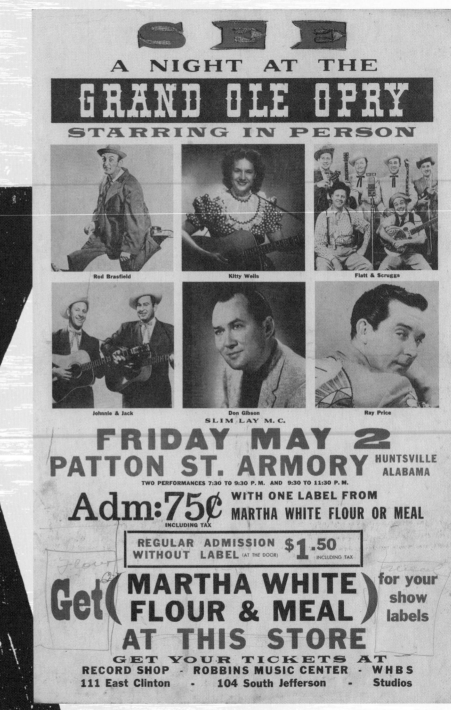

1958

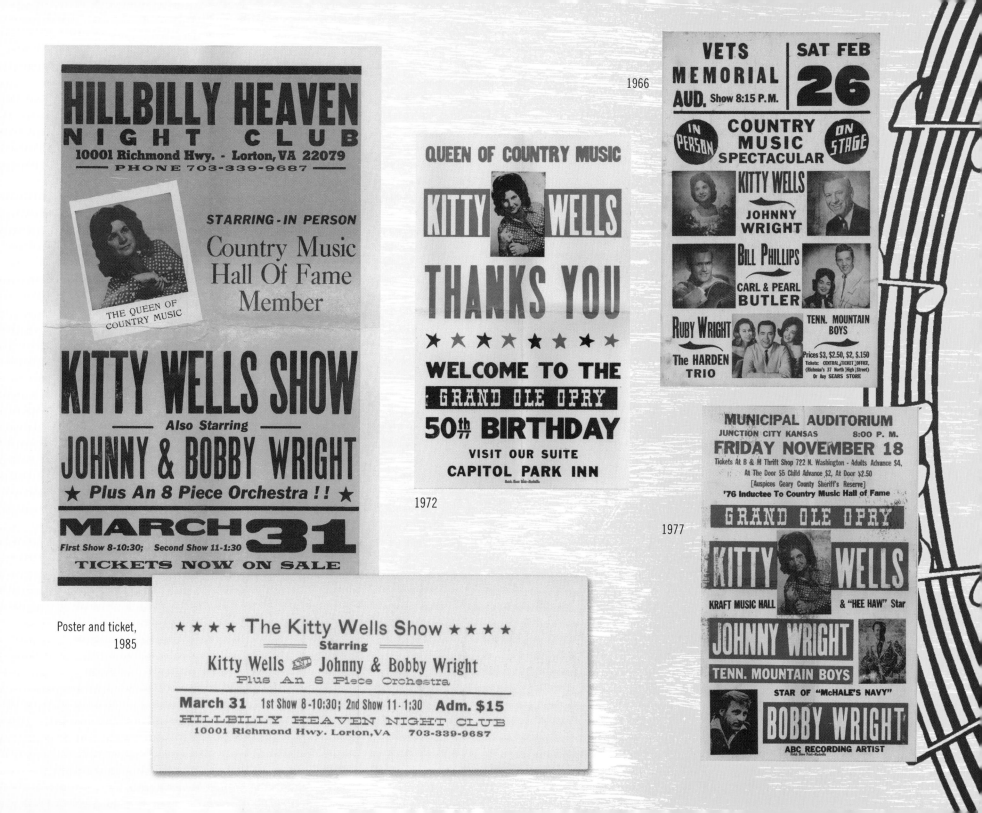

Poster and ticket,
1985

1966

1972

1977

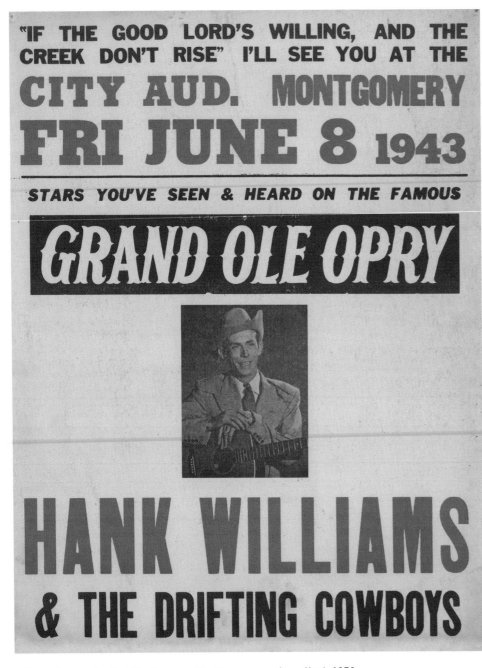

"IF THE GOOD LORD'S WILLING, AND THE CREEK DON'T RISE" I'LL SEE YOU AT THE

CITY AUD. MONTGOMERY
FRI JUNE 8 1943

STARS YOU'VE SEEN & HEARD ON THE FAMOUS

GRAND OLE OPRY

HANK WILLIAMS
& THE DRIFTING COWBOYS

Above: Prop poster that Jim Owen used in his one-man show, *Hank*, 1976

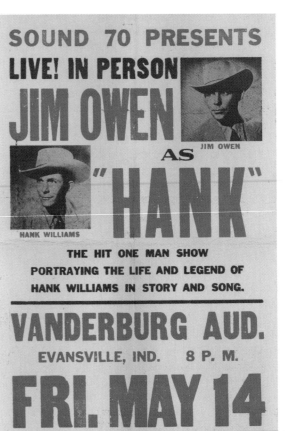

SOUND 70 PRESENTS
LIVE! IN PERSON
JIM OWEN
AS
"HANK"

JIM OWEN

HANK WILLIAMS

THE HIT ONE MAN SHOW
PORTRAYING THE LIFE AND LEGEND OF
HANK WILLIAMS IN STORY AND SONG.

VANDERBURG AUD.
EVANSVILLE, IND. 8 P.M.
FRI. MAY 14

ADVANCE $4.00 - AT DOOR $4.50
TICKETS ON SALE WINEBAUGH PHARMACY

Advertising poster for Jim Owen's touring Hank Williams program, 1976

continued from page 65

Hank Williams impersonator Jim Owen starred in a 1976 PBS television special, *Hank*. Hatch Show Print produced a poster for the show. Reproductions of fake posters for other artists appeared throughout the south, describing other concerts that never were. Hatch Show Print continued to produce posters for real concerts, some of them for journeymen performers such as Ace Cannon and Jimmy Dee.

continued on page 76

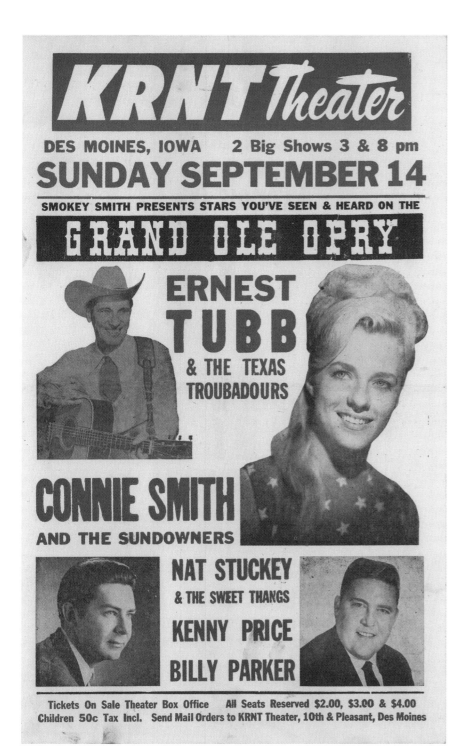

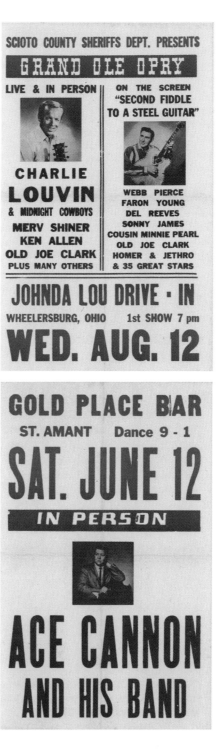

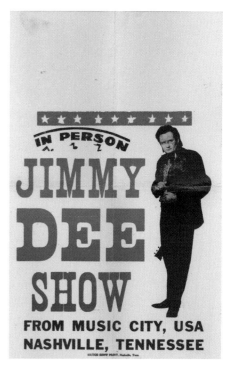

Far left: Poster featuring
Country Music Hall of Fame member
Connie Smith, 1969

Left: 1970 poster advertising
in-person and on-screen performances
at a drive-in

Below, left to right: Posters for
Ace Cannon (1971) and Jimmy Dee
(1979)

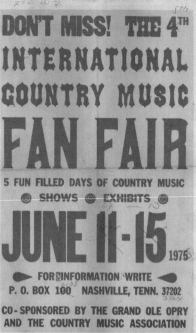

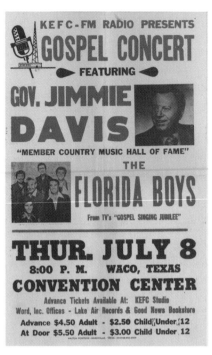

Posters printed just before
the dawn of the digital age.

Top row, from left:
Skull's Rainbow Room, 1975;
1975; Country Music Hall of Fame
member Jimmie Davis, 1976
Bottom row, from left: 1975; 1975;
1971; 1978

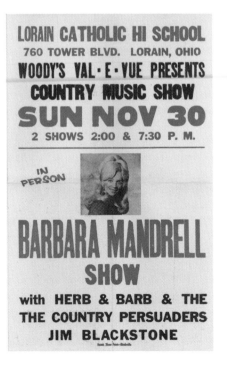

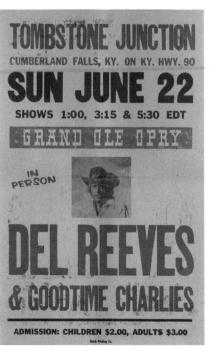

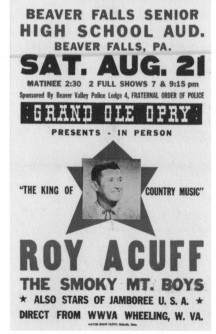

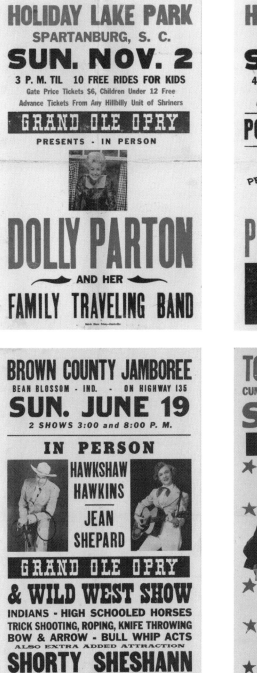

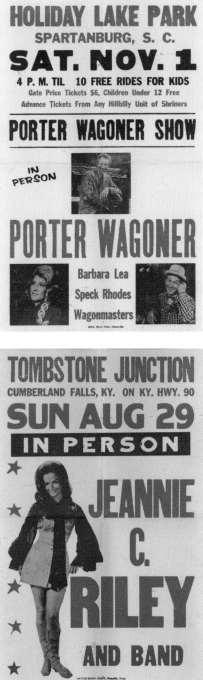

Above: Clients sometimes placed orders for new posters using a marked-up version of the previous one, 1976

Right, clockwise from top left: Dolly Parton and Porter Wagoner played the same venue in 1975, one day apart, shortly after their partnership ended; Jeannie C. Riley, 1976; husband-and-wife team Hawkshaw Hawkins and Jean Shepard, 1960

Right: Three posters printed in 1975

Below, from left: 1978, 1976, 1975

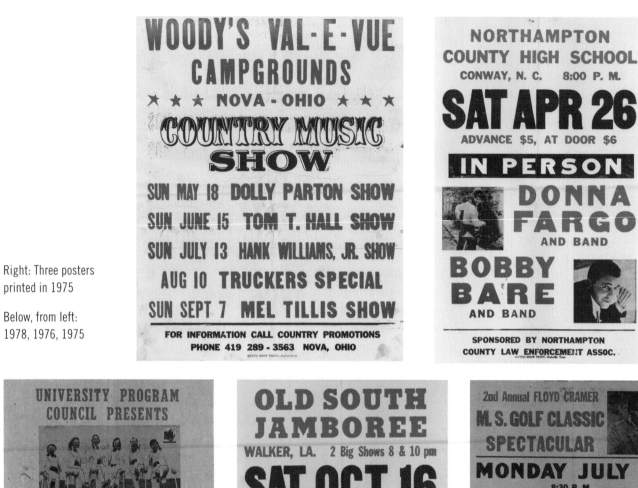

WOODY'S VAL·E·VUE CAMPGROUNDS
★ ★ ★ NOVA · OHIO ★ ★ ★
COUNTRY MUSIC SHOW

SUN MAY 18 DOLLY PARTON SHOW
SUN JUNE 15 TOM T. HALL SHOW
SUN JULY 13 HANK WILLIAMS, JR. SHOW
AUG 10 TRUCKERS SPECIAL
SUN SEPT 7 MEL TILLIS SHOW

FOR INFORMATION CALL COUNTRY PROMOTIONS
PHONE 419 289 - 3563 NOVA, OHIO
HATCH SHOW PRINT—NASHVILLE

NORTHAMPTON COUNTY HIGH SCHOOL
CONWAY, N. C. 8:00 P. M.
SAT APR 26
ADVANCE $5, AT DOOR $6
IN PERSON
DONNA FARGO
AND BAND
BOBBY BARE
AND BAND

SPONSORED BY NORTHAMPTON
COUNTY LAW ENFORCEMENT ASSOC.
HATCH SHOW PRINT, Nashville, Tenn.

SCHOOL AUD.
STANBERRY, MO. 2:30 & 7:30 P. M.
SUN. NOV. 16
Advance Adults $3, Children $2, 50c More At Door
Sponsored By Stanberry Bi - Centennial Committee
STAR YOU'VE SEEN & HEARD ON THE
GRAND OLE OPRY
IN PERSON
MERLE KILGORE
MARVIN MUFFNUCKLE SHOW
CONNIE VANNETTE
Hatch Show Print from Nashville

UNIVERSITY PROGRAM
COUNCIL PRESENTS
BAREFOOT JERRY
SPECIAL GUEST AMBROSE
THURSDAY APRIL 20th
HOOPER EBLEN CENTER
TENN. TECH COOKEVILLE 8:00 P. M.
Tickets $6 Advance, $7 Day Of Show

A MIKETED PRODUCTION

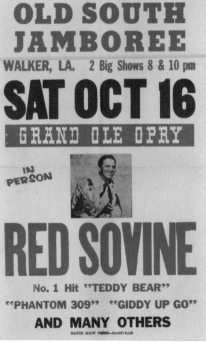

OLD SOUTH JAMBOREE
WALKER, LA. 2 Big Shows 8 & 10 pm
SAT OCT 16
GRAND OLE OPRY
IN PERSON
RED SOVINE
No. 1 Hit "TEDDY BEAR"
"PHANTOM 309" "GIDDY UP GO"
AND MANY OTHERS
HATCH SHOW PRINT—NASHVILLE

2nd Annual FLOYD CRAMER
M. S. GOLF CLASSIC SPECTACULAR
MONDAY JULY 14
8:30 P. M.
GRAND OLE OPRY HOUSE · OPRYLAND
IN PERSON ★ FULL CONCERT
JOHNNY CASH
JUNE CARTER
FLOYD CRAMER
JERRY REED
MEL TILLIS
Plus THE TENNESSEE THREE & MUSIC CITY SOUND OF STRINGS
Ticket Now On Sale Opry Ticket Office, Reserved Seats $8.50, $7.00, $5.50
Net Proceeds Go To National Multiple Sclerosis Research Society

Opposite, clockwise, from left; Hank Williams Jr. headlining a package show, 1976; Audrey Williams, 1970; and Hank Jr., 1975, months before the Montana mountain-climbing accident that nearly claimed his life

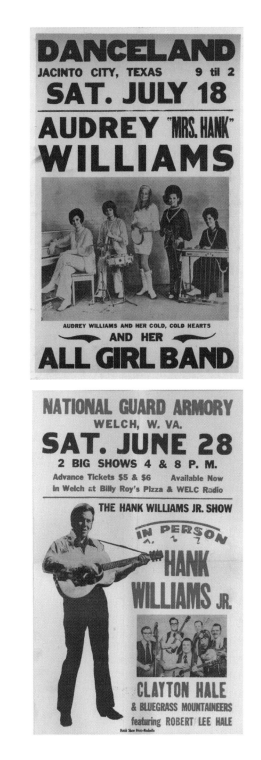

76

continued from page 70

By March 1978, though, poster production had declined to half the volume of just twelve years earlier. Television and FM radio were more efficient and effective advertising methods. The landscape forced Denny to sell his stake in Hatch Show Print in 1978. Still concerned for its preservation, he repurchased the failing business in 1981, and committed to the challenges of the printing business for another four years, even buying needed rollers for the presses.

1974

1984

By the 1980s, most touring artists used other media to advertise their shows, though some still believed in the power of the poster.

Opposite: A map of Nashville's Opryland, late 1980s. The red circle indicates Hatch Show Print's location near the Roy Acuff Museum.

1983

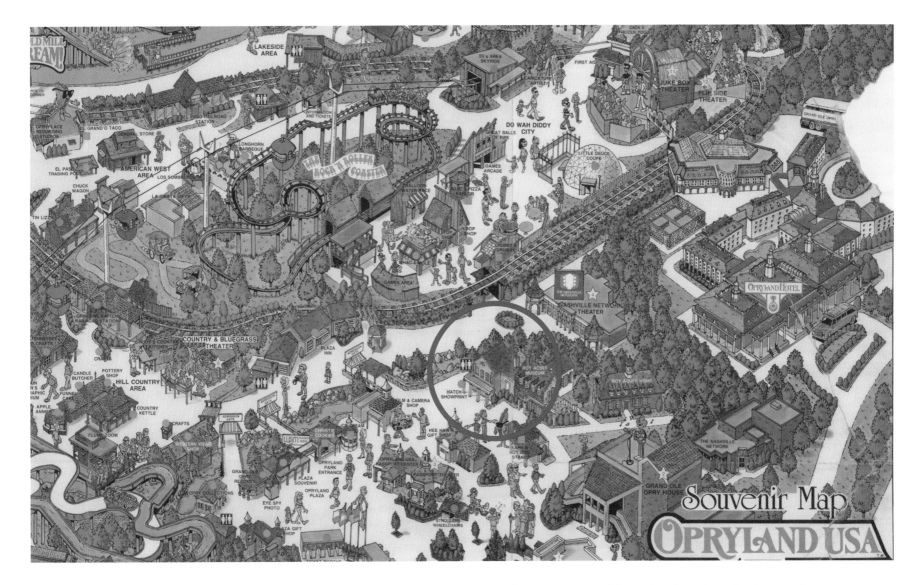

Bill Denny sold Hatch Show Print to Gaylord Entertainment in 1986, for the published figure of $60,000. Though the shop was a curiosity for the large corporation, Denny and Bud Wendell of Gaylord held the fervent hope that Hatch Show Print would continue to be preserved. Gaylord moved a significant portion of the print shop from its Fourth Avenue location to Opryland, to become an attraction in the theme park. The gesture put the shop's poster work in front of country music fans, but it was an existence far removed from the shop's glory days.

MINNIE PEARL

For half a century, Minnie Pearl (1912-1996) was the queen of country comedy. In the late 1930s, Tennessee native Sarah Ophelia Colley (later Sarah Cannon) developed the character of Minnie Pearl, and soon earned a spot on the Grand Ole Opry.

She was known for her down-home, often self-deprecating humor, dowdy dresses, straw hat—festooned with plastic flowers and a $1.98 price tag—and the enthusiastic greeting "How-DEE!" that, along with her hat, became her trademark.

In addition to her regular Opry appearances, she guested on a number of television programs including *The Tonight Show* and *The Carol Burnett Show* before joining the cast of *Hee Haw*.

Minnie was inducted into the Country Music Hall of Fame in 1975. She was a frequent client of Hatch Show Print, using posters to advertise her performances. In 2012, Hatch Show Print made a commemorative poster marking her 100th birthday.

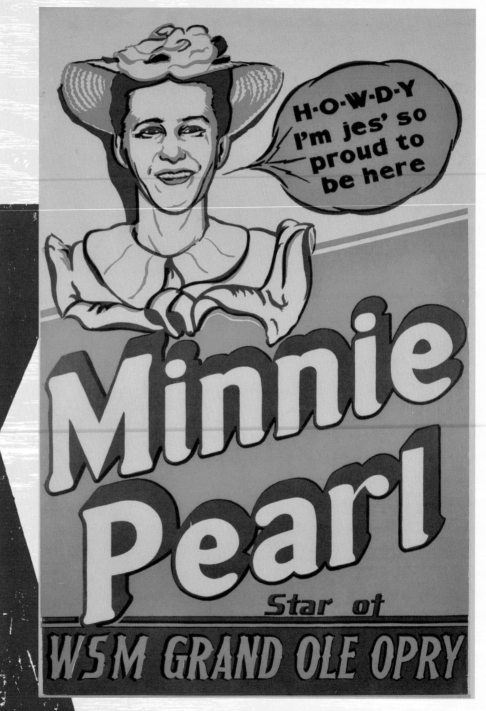

Restrike of c. 1940s poster

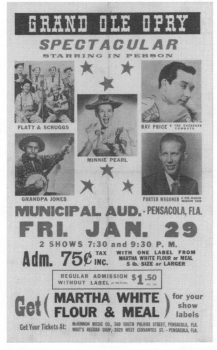

GRAND OLE OPRY
SPECTACULAR
STARRING IN PERSON

FLATT & SCRUGGS

RAY PRICE & THE CHEROKEE COWBOYS

MINNIE PEARL

GRANDPA JONES

PORTER WAGONER & HIS WAGON MASTER TRIO

MUNICIPAL AUD. - PENSACOLA, FLA.
FRI. JAN. 29
2 SHOWS 7:30 and 9:30 P. M.
Adm. 75¢ TAX INC. WITH ONE LABEL FROM MARTHA WHITE FLOUR OR MEAL 5 lb. SIZE or LARGER

REGULAR ADMISSION
WITHOUT LABEL (AT THE DOOR) $1.50 INC. TAX

Get (**MARTHA WHITE FLOUR & MEAL**) for your show labels

Get Your Tickets At: McKINNON MUSIC CO., 500 SOUTH PALAFOX STREET, PENSACOLA, FLA.
WHIT'S RECORD SHOP, 2629 WEST CERVANTES ST. - PENSACOLA, FLA.

1960

NEW FRANKLIN HIGH SCHOOL GYM.
TUE. NIGHT 8 P.M. **DEC. 14**
XMAS BENEFIT BASKETS FOR NEEDY FAMILIES
ADMISSION: $1.00 & 50c TAX INC.

W S M GRAND OLE OPRY
PRESENTS - IN PERSON
MINNIE PEARL
KITTY WELLS
JOHNNIE & JACK
LEW CHILDRE
RUBY WELLS · BOBBY WRIGHT
SAM & KIRK McGHEE
DUKE OF PADUCAH
TENNESSEE MOUNTAIN BOYS

1954

ATTICA INDEPENDENT FAIR
ATTICA - OHIO
THU. AUG. 7
W S M GRAND OLE OPRY
PRESENTS - IN PERSON
THE
MINNIE PEARL
SHOW SHOW
★ RED SOVINE
★ THE GLASER BROS.
★ BUN WILSON (COMEDIAN)
★ BOBBY SYKES & BAND

1958

Photoplate for poster shown above

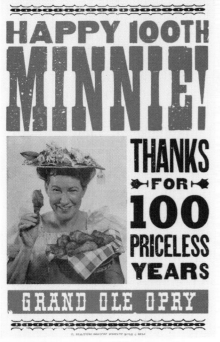

HAPPY 100TH
MINNIE!
THANKS
FOR
100
PRICELESS
YEARS
GRAND OLE OPRY

2012

MINNIE PEARL
SHOW
THE PRIDE OF "GRINDERS SWITCH"
OF
W S M GRAND OLE OPRY
FEATURING
10 - PEOPLE - 10
BEING REPRESENTED EXCLUSIVELY BY
BARNES & CARRUTHERS

ROOM_____

1957

JOHNNY CASH

An international country music ambassador, Johnny Cash (1932–2003) connected with prisoners and presidents, rebels and religious figures.

Born in Kingsland, Arkansas, he grew up in a government community for struggling farmers. This nurtured his empathy for the less fortunate, with whom he identified as the Man in Black.

Beginning with his 1955 Sun Records recordings, Cash relied on a spare, rolling train sound, using an electric guitar, acoustic bass, his own acoustic guitar, and drums to frame his deep, authoritative voice. Hits such as "I Walk the Line" and "Ring of Fire" pointed him toward superstardom. In the 1980s, with Waylon Jennings, Willie Nelson, and Kris Kristofferson, Cash formed the Highwaymen. His success continued into the 1990s and beyond with his *American Recordings* album series.

Hatch Show Print's restrikes of historic Cash posters remain among the shop's most popular items.

LIVE & IN PERSON
JOHNNY CASH
★ ONE NIGHT ONLY ★
SMYRNA TENNESSEE
SEPT. 27
SPONSORED BY NISSAN

COPYRIGHT 1997 ★ HATCH SHOW PRINT CO. ★ AMERICAN LETTERPRESS POSTERS SINCE 1879

1997

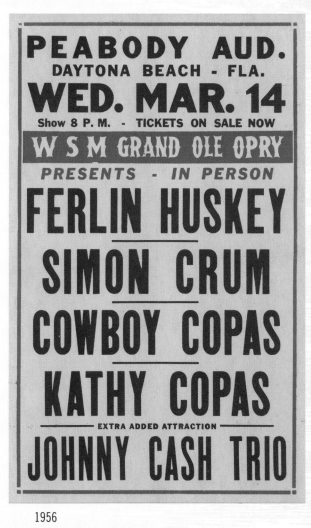

PEABODY AUD.
DAYTONA BEACH - FLA.
WED. MAR. 14
Show 8 P.M. - TICKETS ON SALE NOW
W S M GRAND OLE OPRY
PRESENTS - IN PERSON
FERLIN HUSKEY
SIMON CRUM
COWBOY COPAS
KATHY COPAS
EXTRA ADDED ATTRACTION
JOHNNY CASH TRIO

1956

JOHNNY CASH
WE WALK THE LINE
A Celebration of the Music of Johnny Cash
80TH BIRTHDAY CELEBRATION
APRIL 20 **AUSTIN**
2012 **TEXAS**
featuring
WILLIE NELSON • KRIS KRISTOFFERSON • SHERYL CROW • PAT MONAHAN • RONNIE DUNN
LUCINDA WILLIAMS • AMY LEE • SHOOTER JENNINGS • JAMEY JOHNSON • SHELBY LYNNE
RHETT MILLER • ANDY GRAMMAR • BRANDI CARLILE • CAROLINA CHOCOLATE DROPS
IRON & WINE • DON WAS • BUDDY MILLER • KENNY ARONOFF • IAN McLAGAN • GREG LEISZ
and more special guests

c.2012 Hatch Show Print®

2012

MINNEAPOLIS
AUDITORIUM
SAT APR 22
SHOW 8:30 pm BlockBuster Number 18
SMOKEY SMITH Presents
THE FABULOUS
JOHNNY
CASH
SHOW
JUNE CARTER
THE TENN. THREE
MOTHER MAYBELLE &
CARTER FAMILY
The STATLER BROS.
CARL PERKINS

TICKETS ON SALE
DOWNTOWN TICKET OFFICE - MINNEAPOLIS
FIELD SCHLICK TICKET OFFICE - ST. PAUL
EVERY SEAT RESERVED $1.50 - $3.00 - $2.50 - $2.00

Under license with the John R. Cash Revocable Trust Reprinted from the original plates C.2012 Hatch Show Print ®

1967

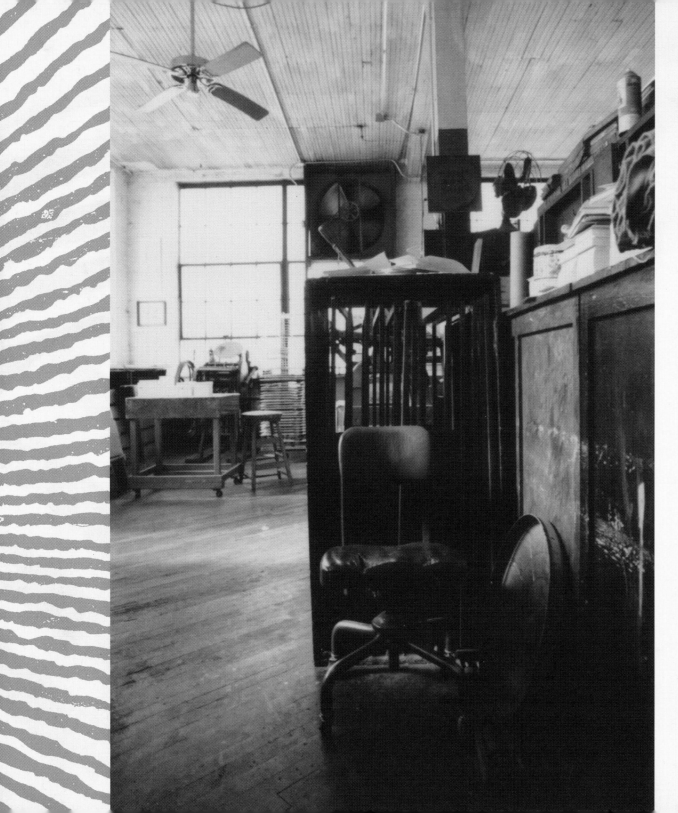

While Hatch Show Print endured this division into two parts, the Country Music Hall of Fame and Museum was invited to assess what was still in the old building downtown, and explore ideas for reinvigorating the shop. The first step was to inventory the contents by archiving and reprinting the old wood blocks and photoplates.

Restrikes of posters for Elvis and Hank were sold wholesale to keep money coming in. Inside the nearly abandoned Ryman Auditorium, tourists could purchase a poster for five dollars after singing "You Are My Sunshine," standing on the same stage where the Opry once played.

Interior of the print shop at the Fourth Avenue location, mid-1980s

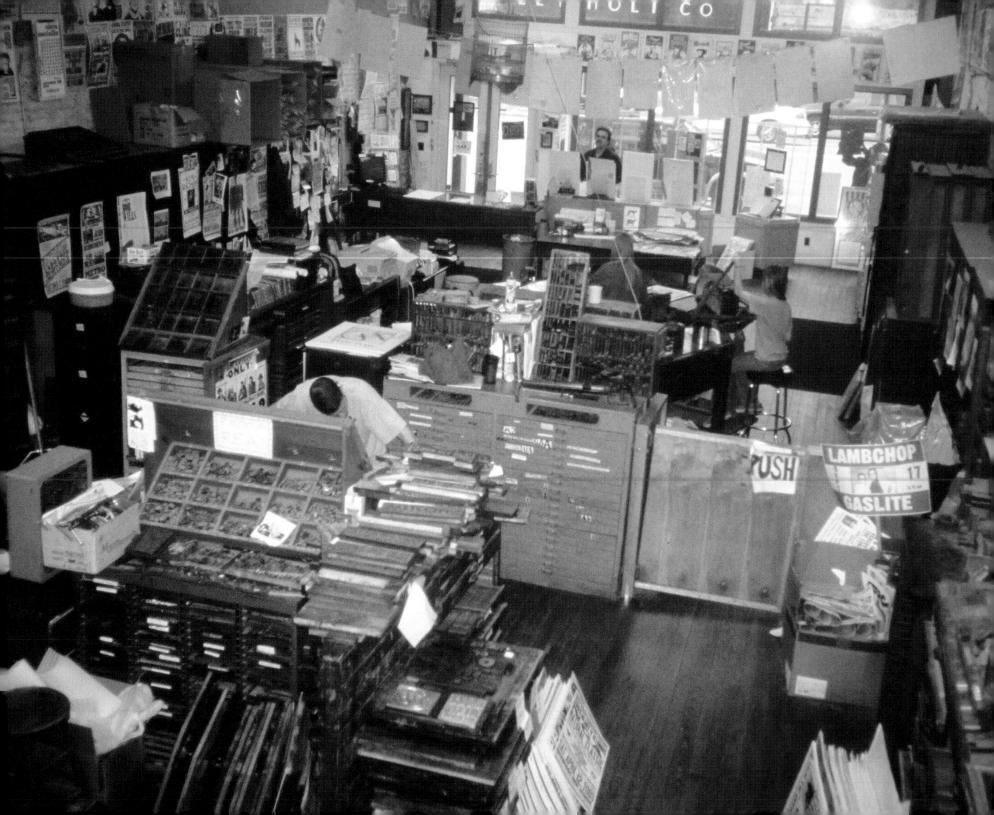

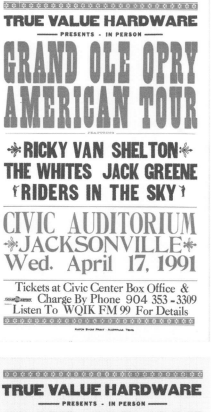

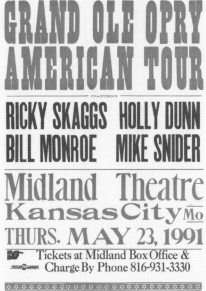

As downtown Nashville reawakened in the early 1990s, following years of seedy dissolution, Gaylord Entertainment donated Hatch Show Print to the Museum. In 1992, the shop relocated to 316 Broadway, one of the few vacant buildings large enough to hold the entirety of the shop's contents. Gaylord had already shuttered the tourist attraction and graciously returned the warehoused portion of the shop to the new Hatch Show Print location. Under the protection and guidance of the Country Music Hall of Fame and Museum, the print shop prepared to live up to its new, self-imposed mandate: preservation through production.

At the same time, a music community-wide effort was underway in Nashville to save the Ryman Auditorium. Renewed interest in its fate inspired Gaylord Entertainment to renovate what was known as the "Mother Church of Country Music," and welcome live entertainment to its stage once again.

continued on page 92

Left: After a period of time without a traceable stream of revenue, the shop produced multiple runs of posters to advertise the *Grand Ole Opry American Tour*, in 1991.

Opposite: Interior of the print shop after it moved to Broadway, c. 1992

BRENDA LEE

Brenda Lee (b. 1944) is one of Nashville's most versatile singers, finding success in country and pop music and on both sides of the Atlantic in the 1950s, '60s, and '70s.

At age five, Lee won her first singing contest. In 1956, she became a regular on *Ozark Jubilee*, a country music television show hosted by Red Foley. By twelve, she had a recording contract.

The diminutive singer with the big voice earned the nickname "Little Miss Dynamite" in 1957 after releasing the single "Dynamite." Hits such as "Sweet Nothin's," "I'm Sorry," and "Nobody Wins" followed. Her "Rockin' Around the Christmas Tree" remains a classic more than sixty years after its recording.

Lee was inducted into the Country Music Hall of Fame in 1997. In 2009, she was the subject of an exhibition at the Country Music Hall of Fame and Museum; a Hatch Show Print poster promised a *Dynamite* grand opening.

1961

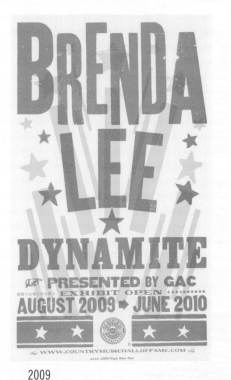

BRENDA LEE
★
DYNAMITE
PRESENTED BY GAC
EXHIBIT OPEN
AUGUST 2009 → JUNE 2010
WWW.COUNTRYMUSICHALLOFFAME.COM

2009

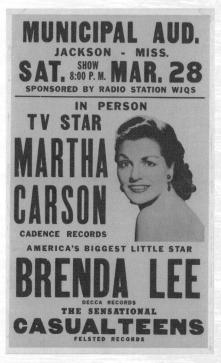

MUNICIPAL AUD.
JACKSON - MISS.
SAT. SHOW 8:00 P.M. MAR. 28
SPONSORED BY RADIO STATION WJQS
IN PERSON
TV STAR
MARTHA CARSON
CADENCE RECORDS
AMERICA'S BIGGEST LITTLE STAR
BRENDA LEE
DECCA RECORDS
THE SENSATIONAL
CASUALTEENS
FELSTED RECORDS

1959

WELCOME DJ's
BRENDA LEE
ROCKIN' AROUND THE CHRISTMAS TREE
DECCA

1958

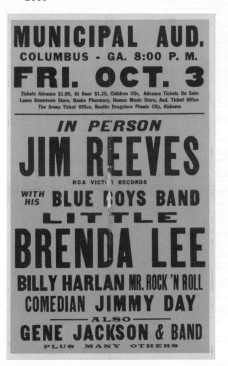

MUNICIPAL AUD.
COLUMBUS - GA. 8:00 P.M.
FRI. OCT. 3
Tickets Advance $1.00, At Door $1.25, Children 50c, Advance Tickets On Sale:
Lanes Downtown Store, Banks Pharmacy, Humes Music Store, Aud. Ticket Office
The Arena Ticket Office, Booths Drugstore Phenix City, Alabama
IN PERSON
JIM REEVES
RCA VICTOR RECORDS
WITH HIS BLUE BOYS BAND
LITTLE
BRENDA LEE
BILLY HARLAN MR. ROCK 'N ROLL
COMEDIAN JIMMY DAY
ALSO
GENE JACKSON & BAND
PLUS MANY OTHERS

1958

BRENTWOOD ACADEMY
WED. APR. 16 7:30 P.M.
THE
BRENDA LEE
SHOW
WITH
JACKY WARD
Tickets $5.00
Available at the school or any B. A. student

1980

LORETTA LYNN

Despite growing up poor, marrying in her mid-teens, and having four children by age twenty, Loretta Lynn (b. 1932) became one of country music's most successful performers.

Born in Butcher Holler, Kentucky, Lynn began singing professionally after her husband noticed her strong voice and prodded her to become an entertainer. Her first single, "I'm a Honky Tonk Girl," reached #14 on the country charts in 1960. Nashville noticed, and she signed with Decca Records. Her music took a more personal turn in the mid-1960s, and assertive songs such as "Fist City" led the way for female singer-songwriters.

Throughout her career, Lynn refused to shy away from controversial topics in her songs. She recorded critically acclaimed collaborations with Conway Twitty and Jack White and has remained active into her eighties.

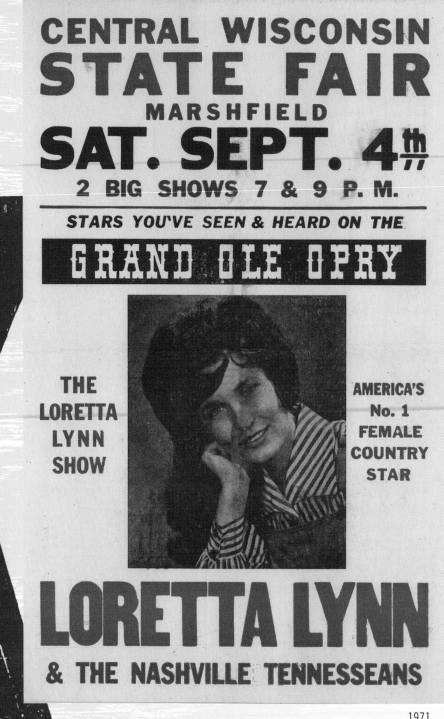

1971

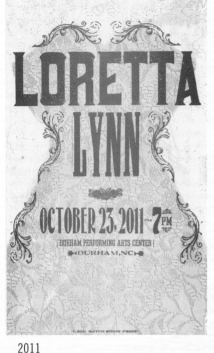

2011

LORETTA LYNN

CELEBRATES
50 YEARS

AS A MEMBER OF THE
GRAND OLE OPRY
★ 1962 · 2012 ★

2012

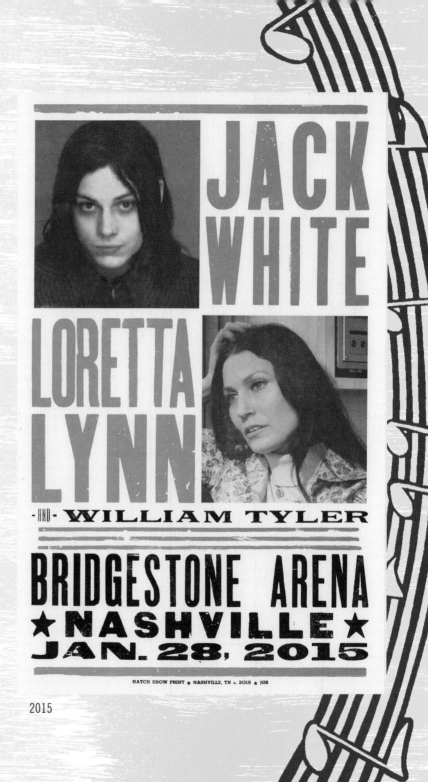

JACK WHITE
LORETTA LYNN
AND WILLIAM TYLER
BRIDGESTONE ARENA
★ NASHVILLE ★
JAN. 28, 2015

2015

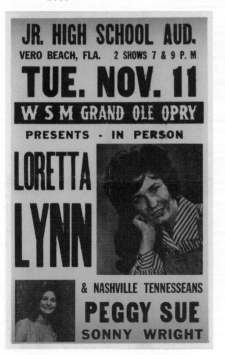

JR. HIGH SCHOOL AUD.
VERO BEACH, FLA. 2 SHOWS 7 & 9 P.M.
TUE. NOV. 11
WSM GRAND OLE OPRY
PRESENTS - IN PERSON
LORETTA LYNN
& NASHVILLE TENNESSEANS
PEGGY SUE
SONNY WRIGHT

1969

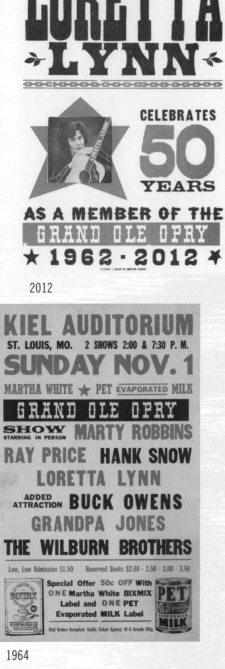

KIEL AUDITORIUM
ST. LOUIS, MO. 2 SHOWS 2:00 & 7:30 P.M.
SUNDAY NOV. 1
MARTHA WHITE ★ PET EVAPORATED MILK
GRAND OLE OPRY
SHOW STARRING IN PERSON MARTY ROBBINS
RAY PRICE HANK SNOW
LORETTA LYNN
ADDED ATTRACTION BUCK OWENS
GRANDPA JONES
THE WILBURN BROTHERS
Low, Low Admission $1.50 Reserved Seats $2.00 - 2.50 - 3.00 - 3.50
Special Offer 50c OFF With ONE Martha White BIXMIX Label and ONE PET Evaporated MILK Label

1964

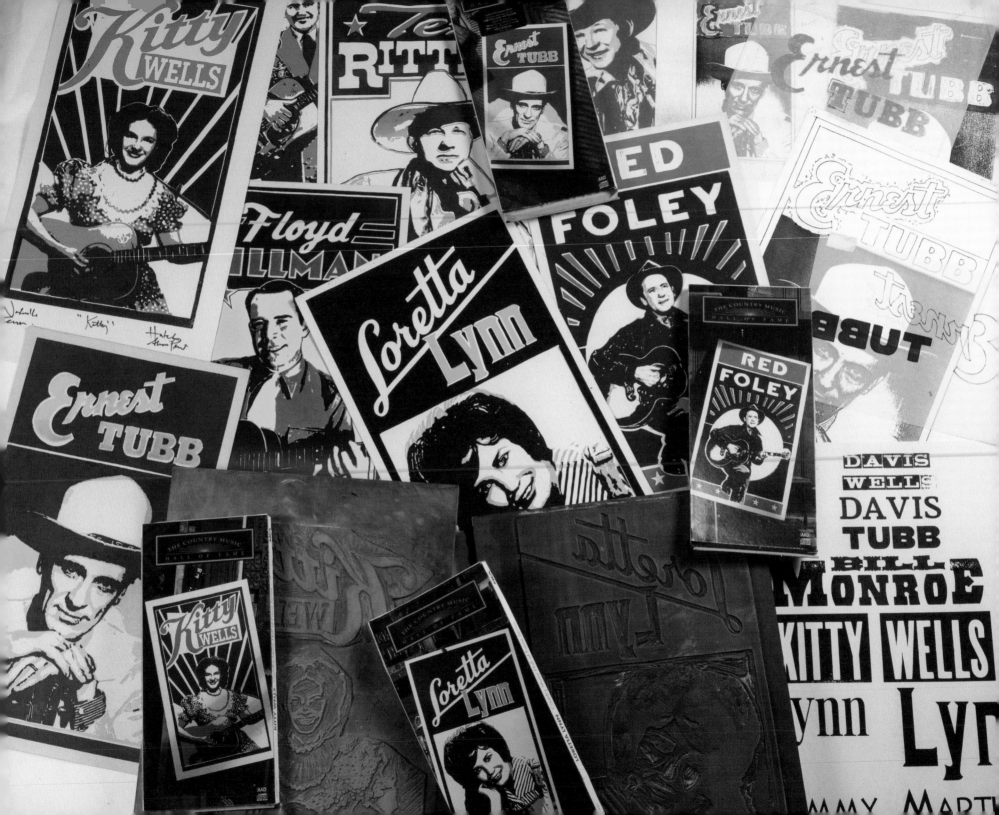

Sketches, linocuts, printed proofs, and color studies are what remain of the process of design in letterpress printing.

Opposite: Artwork and process material for the MCA-Country Music Hall of Fame CD Series, 1991.

This page: Design process elements for Emmylou Harris and the Nash Ramblers' *At the Ryman*, 1992

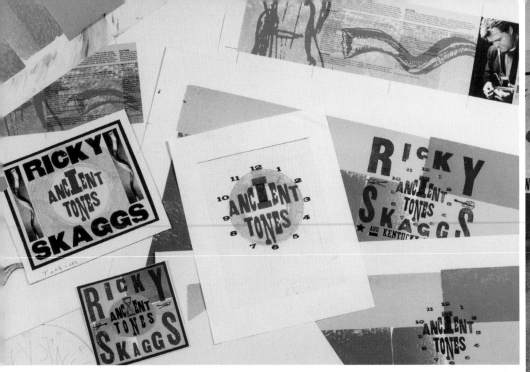

Above: Studies and proofs for Ricky Skaggs's 1999 album, *Ancient Tones*

Right: Proofs for Hank Williams tribute *På Norsk* (1995) and color studies
for *Turn Back the Years* box set (2005)

continued from page 85

Music Row's interest in the shop returned, lured by the
now-distinctive aesthetic of letterpress print. MCA Records
commissioned fifteen pieces of cover art celebrating fifteen members
of the Country Music Hall of Fame (ten of which were created
at the Fourth Avenue location). Warner Bros. Records sought a
cover for Emmylou Harris's historic live record *At The Ryman*,
and the print shop produced several Hank Williams album covers.
Sony Music paid the print shop a healthy fee to typeset the words
"Bob Wills and His Texas Playboys" for its reissue of *The King of
Western Swing*, as well.

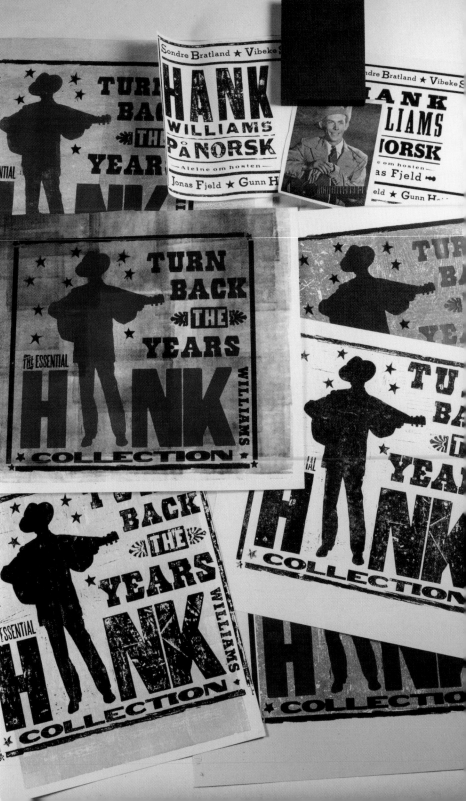

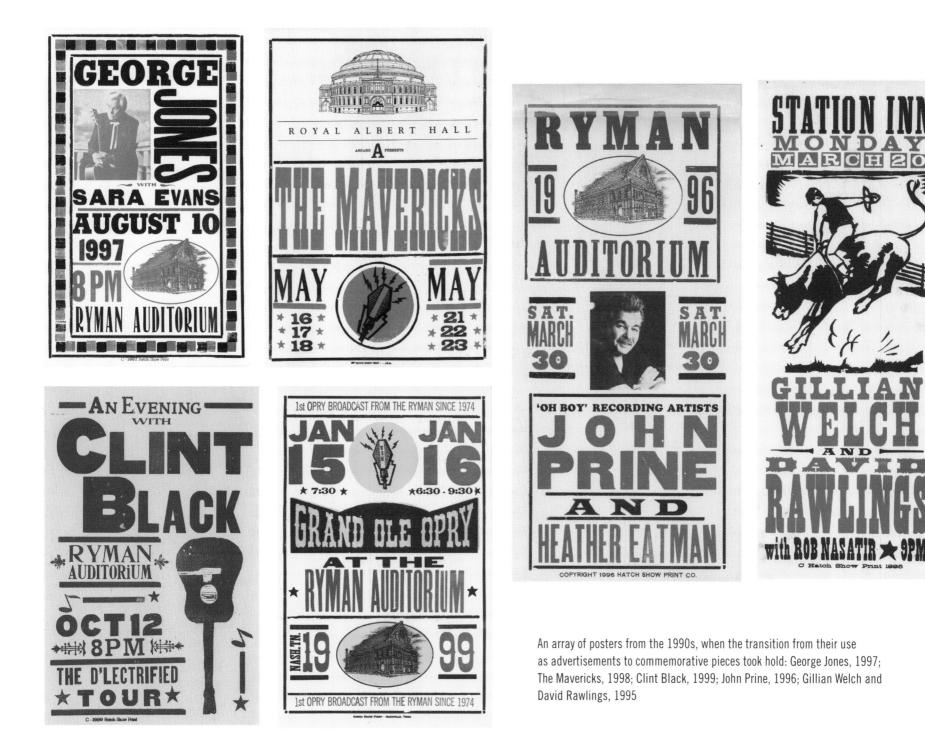

An array of posters from the 1990s, when the transition from their use
as advertisements to commemorative pieces took hold: George Jones, 1997;
The Mavericks, 1998; Clint Black, 1999; John Prine, 1996; Gillian Welch and
David Rawlings, 1995

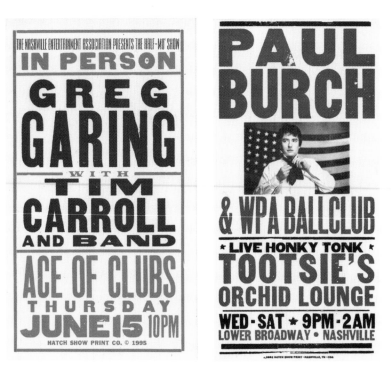

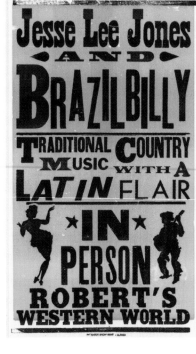

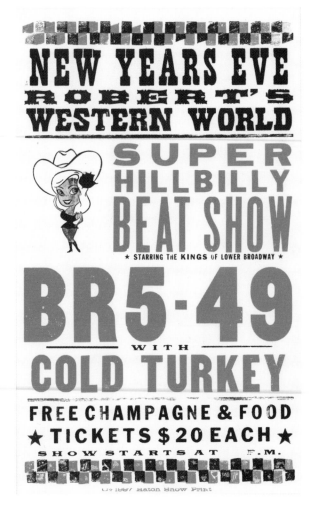

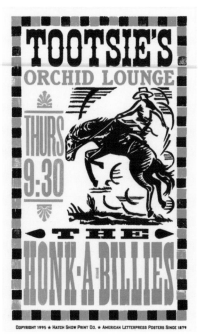

Nightclubs bringing in traditionally styled musical acts such as Greg Garing, BR5-49, Paul Burch, and Brazilbilly to Nashville's "Lower Broad," the city blocks on Broadway closest to the Cumberland River, attracted locals and visitors alike. The Ryman Auditorium, thanks in large part to the efforts of Harris, reopened as a formidable music venue. Posters were ordered from Hatch Show Print to advertise shows in the honky-tonks, and to commemorate each new show or entertainer's performance at the Mother Church. Curious crowds began pouring into the retail area at the front of the print shop, seeking posters, a tactile, tangible connection to their Music City experience.

The 1990s resurgence of Nashville's Lower Broadway was spurred, in part, by tradition-minded performers who frequented the honky-tonks.

Clockwise from left: Greg Garing, 1995; Paul Burch, 2003; Brazilbilly, 1999; BR5-49, 1997; Honk-A-Billies, 1995.

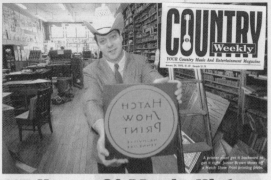

115 Years Of Music History

Hatch Show Print As Popular As Ever

They have country in their hearts, but Emmylou Harris, Ricky Skaggs, Marty Stuart and Junior Brown have printer's ink coursing through their veins.

They're among the stars who feel a strong connection to and affection for historic Hatch Show Print, the 115-year-old Nashville poster shop owned and operated by the Country Music Foundation.

"I discovered Hatch the first time I came to Nashville in the early '70s," Brown told

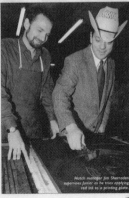

COUNTRY WEEKLY during one of his frequent visits to the fascinating facility.

Other visitors have included Travis Tritt, Mark Collie, Bill Monroe, Deborah Allen, Bob Woodruff, Billy Gibbons of ZZ Top and Col. Tom Parker. Alan Jackson even shot a video there.

Why are these celebrities attracted to Hatch?

"The heritage and the history," explained Brown, a Curb recording artist who uses the distinctive Hatch motif in his publicity kit as well as Hatch posters to advertise his shows.

"People like to have the posters as a souvenir. The way Hatch makes them is really nice to look at. I know a lot of people collect them. I certainly do. My collection goes all the way back."

Bill Ivey, director of the nonprofit CMF, told us Hatch can trace the history of The Grand Ole Opry through its tiles and poster plates. Many of the original wood plates are still in stock.

"Some of the very earliest posters from the '20s have been lost ... but we do have items going back to the '30s. It's the contemporary stars like Junior who have a particular interest in country

history, and they're the ones who are drawn to Hatch."

"Graphic designers see Hatch as a mecca for unique wood type no longer available in the United States," said shop manager Jim Sherraden.

One of the shop's newest clients was also one of its oldest – Ryman Auditorium. Home of The Grand Ole Opry from 1943-74, it was a Hatch customer from the late 1930s until the 1970s. The building reopened as a 2,000-seat performance hall in June.

So, Hatch has come full circle.

For $3-$15, the shop sells restrikes from the original wood plates of country music, vaudeville, carnival, circus and sports posters. But the shop's three staffers also create new works of art in Hatch's primitive but distinctive style.

Sherraden described that style as "basic, easy to read, one to two colors – sometimes three. The printing is pleasantly unsophisticated."

Concluded Sherraden, "We have a drawer full of thank-you notes from people who were happy to discover an out-of-the-way place that reminds them of what country music is all about."

— Bruce Honick

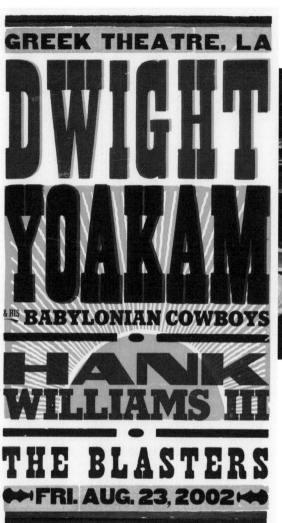

Far left: Junior Brown visits Hatch Show Print for a *Country Weekly* feature in 1995.

Left: Dwight Yoakam poster, 2003

Above: Yoakam spends time in the shop, 2002

As digital technology began to streamline and modernize the processes and output of the graphic design industry, clients seeking the old, rare, hand-set wood and metal type turned to Hatch Show Print for its distinctive styles. Multiple publications featured the shop, including *Country Weekly* (which chronicled a visit from Junior Brown). Dwight Yoakam became such a frequent visitor that the staff joked, "We oughta just give him the keys to the front door."

1993

1997

2003

2009

Around the same time, tribute performances and plays touring the country focused on the legends of country music, which meant that the likenesses of Hank Williams, Patsy Cline, Johnny Cash, and Tammy Wynette began reappearing on commemorative posters. The Grand Ole Opry established a tradition of ordering official Hatch Show Print posters for their inductees, such as Ralph Stanley in 2000, Terri Clark in 2004, and Old Crow Medicine Show in 2013, in addition to posters for most events at the ever-popular Ryman Auditorium.

continued on page 102

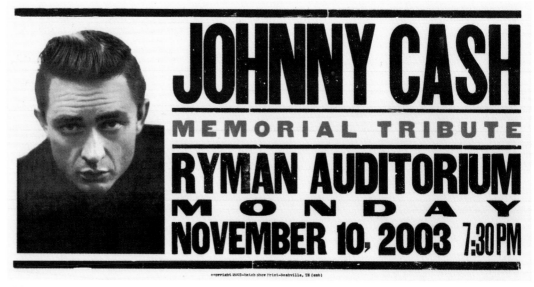

2003

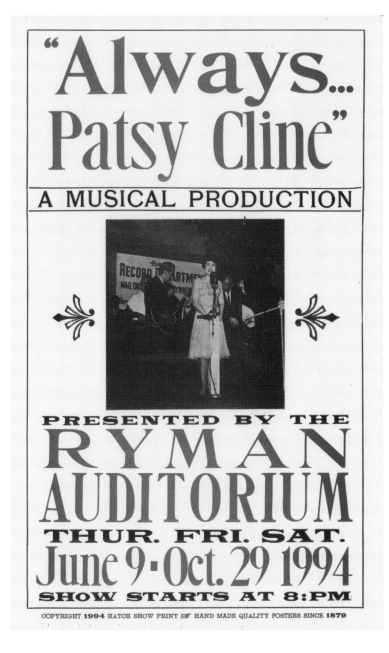

Above: *Always...Patsy Cline* was the first theatrical production in the renovated Ryman Auditorium, 1994.

Right: Posters commemorating inductions into the Grand Ole Opry

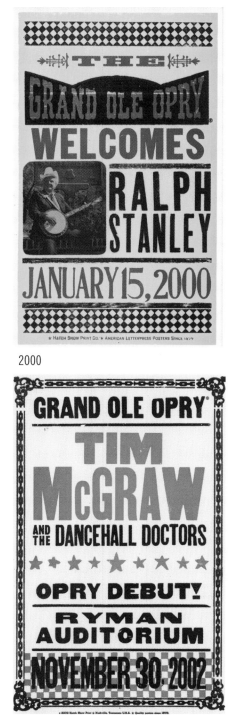

2000

2002

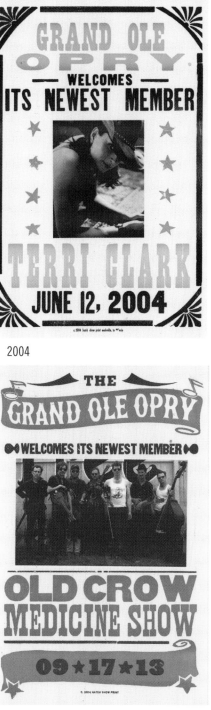

2004

2013

HANK SNOW

Canadian country artist Hank Snow (1914–1999) combined distinctive vocals, skillful guitar playing, and excellent songwriting to become a leading country star.

In his teens, Snow escaped an abusive stepfather by working on a fishing trawler, where he entertained the crew with his music.

Between 1936 and 1949, Snow recorded for the Bluebird label's Canadian division. His career took off after Ernest Tubb convinced the Grand Ole Opry to accept him and RCA released the Snow original "I'm Moving On," which spent forty-four weeks on the country charts in 1950 and 1951. Into the mid-1960s, he topped the country charts with hits such as "I Don't Hurt Anymore" and "I've Been Everywhere." From 1949 to 1980, eighty-five Hank Snow singles reached the charts.

Hatch Show Print made Snow's posters beginning in the early 1950s, including advertisements for package shows where Snow was accompanied by a young, not-yet-famous singer named Elvis Presley.

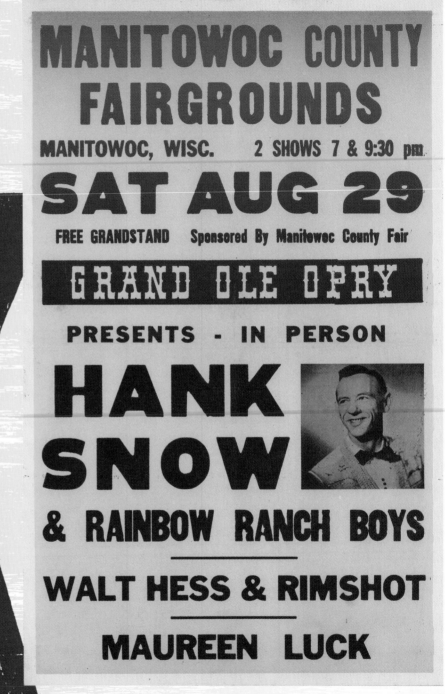

1970

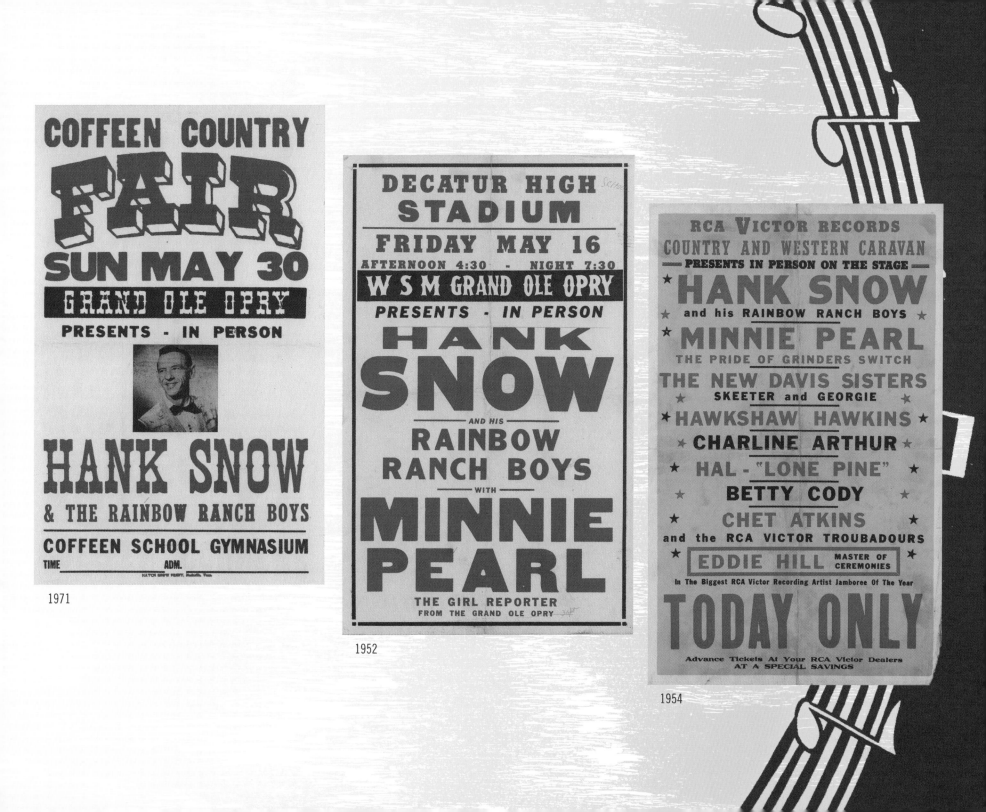

COFFEEN COUNTRY FAIR
SUN MAY 30
GRAND OLE OPRY
PRESENTS - IN PERSON

HANK SNOW
& THE RAINBOW RANCH BOYS

COFFEEN SCHOOL GYMNASIUM
TIME ADM.

HATCH SHOW PRINT, Nashville, Tenn.

1971

DECATUR HIGH STADIUM
FRIDAY MAY 16
AFTERNOON 4:30 - NIGHT 7:30
W S M GRAND OLE OPRY
PRESENTS - IN PERSON
HANK SNOW
AND HIS
RAINBOW RANCH BOYS
WITH
MINNIE PEARL
THE GIRL REPORTER
FROM THE GRAND OLE OPRY

1952

RCA VICTOR RECORDS
COUNTRY AND WESTERN CARAVAN
PRESENTS IN PERSON ON THE STAGE
★ HANK SNOW
and his RAINBOW RANCH BOYS
★ MINNIE PEARL
THE PRIDE OF GRINDERS SWITCH
★ THE NEW DAVIS SISTERS
SKEETER and GEORGIE
★ HAWKSHAW HAWKINS ★
★ CHARLINE ARTHUR ★
★ HAL - "LONE PINE" ★
★ BETTY CODY ★
★ CHET ATKINS ★
and the RCA VICTOR TROUBADOURS
★ EDDIE HILL MASTER OF CEREMONIES ★
In The Biggest RCA Victor Recording Artist Jamboree Of The Year
TODAY ONLY
Advance Tickets At Your RCA Victor Dealers
AT A SPECIAL SAVINGS

1954

GEORGE JONES

George Jones's (1931–2013) remarkable vocal range and emotive delivery made him one of country music's most admired artists. His drama-filled life, with its trials and triumphs, gave his work a realism that resonated with his fans.

Born in Saratoga, an East Texas oil patch settlement, Jones sang for tips on the streets of Beaumont as a boy. He recorded his first Top Five hit, "Why, Baby Why," in 1955. His hits stretched across the decades into the early 1990s, including #1s such as "White Lightning" and "The Grand Tour."

Battles with drugs and alcohol interrupted Jones's career until his million-selling "He Stopped Loving Her Today" helped him win CMA's Male Vocalist of the Year award in 1980 and 1981.

With help from his fourth wife, Nancy, Jones regained his focus and recorded critically acclaimed albums for the rest of his life.

1985

1970

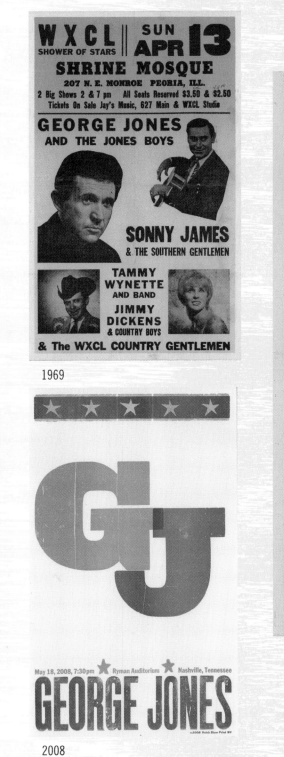

1969

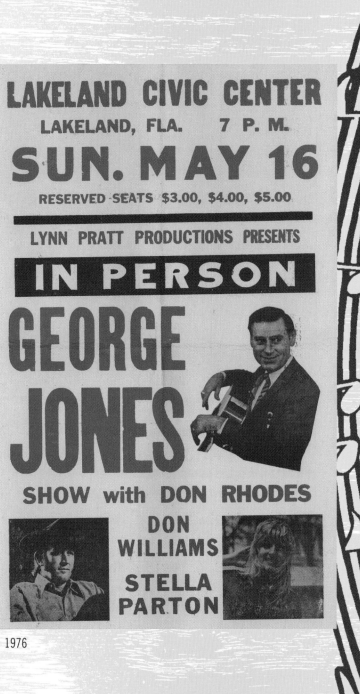

1976

THE LEAKESVILLE JAYCEES
PROUDLY PRESENT
FROM NASHVILLE - TENN.
(GREENE COUNTY'S OWN)
DOUG PIERCE
ALONG WITH
GEORGE JONES
JONES BOYS
AND OTHER SPECIAL GUESTS
AT

Show Time 7:00 P. M. - Tickets $4.00 at Door

1979

May 18, 2008, 7:30 pm ★ Ryman Auditorium ★ Nashville, Tennessee
GEORGE JONES

2008

Willie Nelson posters, from left: 2014; 2010; and 2008

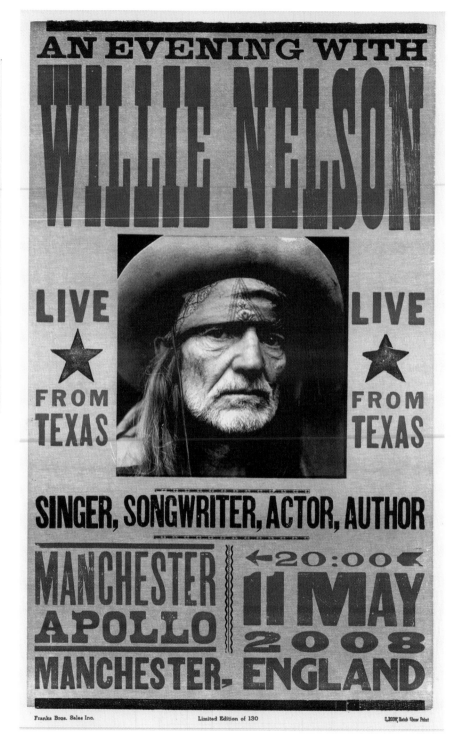

continued from page 96

Willie Nelson ordered so many posters to sell on the road that the shop created numerous designs to satisfy the entertainer's dedicated fan base. A review of the records reveals just thirty jobs produced for the country music genre between 1986 and 1992. By 2002, the number had jumped to over 150 per year. Country clients such as Alan Jackson, the Dixie Chicks, Kenny Chesney, and Alison Krauss and Union Station drove the revival, alongside acts such as the Cowslingers, who eschewed traditional country sounds, but embraced the genre's traditions, up to and including show posters from Hatch Show Print.

continued on page 110

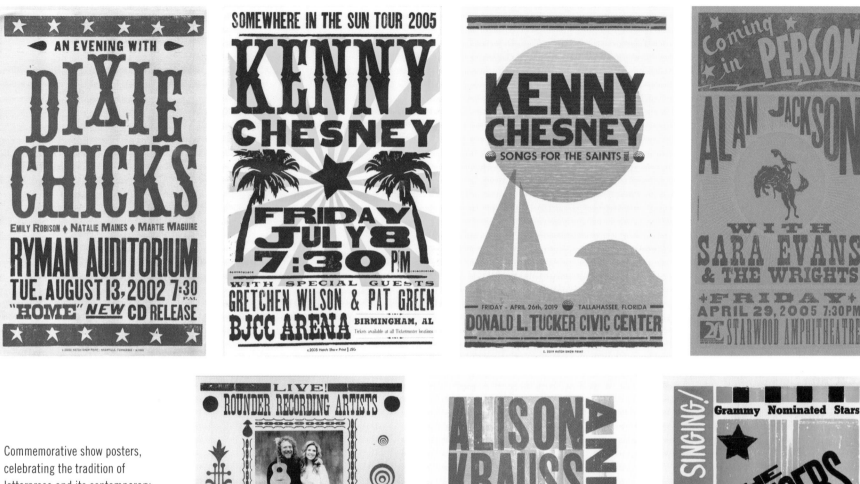

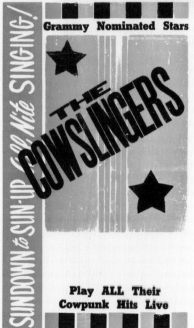

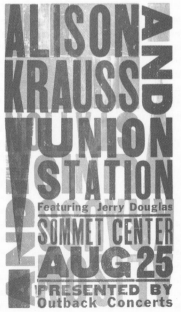

Commemorative show posters, celebrating the tradition of letterpress and its contemporary application

Clockwise from upper left: Dixie Chicks, 2002; Kenny Chesney, 2005 and 2019; Alan Jackson, 2005; Alison Krauss and Robert Plant, 2008; Alison Krauss and Union Station, 2007; The Cowslingers, 2002

2008

2013

1998

2010

2011

2012

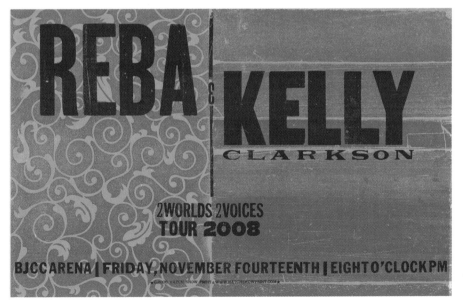

2008

2010

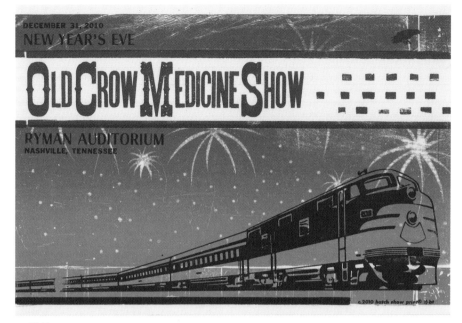

2010

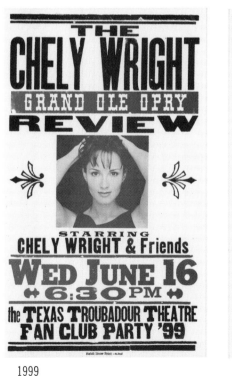

1999

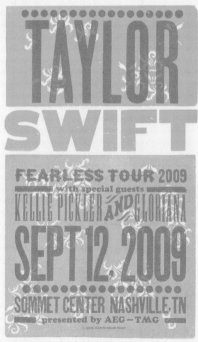

2009

MERLE HAGGARD

Merle Haggard (1937-2016) is arguably the most talented and prolific songwriter country music has yet produced, as well as a versatile artist who mined honky-tonk, blues, jazz, pop, and folk music.

Born to Oklahoma migrant workers in Bakersfield, California, Haggard was a rebellious teenager. Several run-ins with the law finally landed him in San Quentin State Prison for burglary.

Resolving to turn his life around, he aimed for a musical career after his parole in 1960 and signed with a small Bakersfield label. His single "(My Friends Are Gonna Be) Strangers" reached the country Top Ten in 1965. He went on to record thirty-eight chart-topping country hits, and his successful albums stretched into the 2000s.

His songs, including "Okie from Muskogee," "Mama Tried," and "Working Man Blues," explored a multitude of emotions and musical styles. His success helped establish Bakersfield, California, as an important country music center.

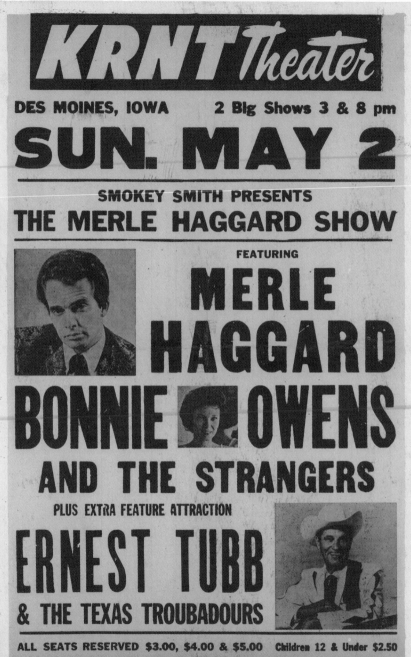

1971

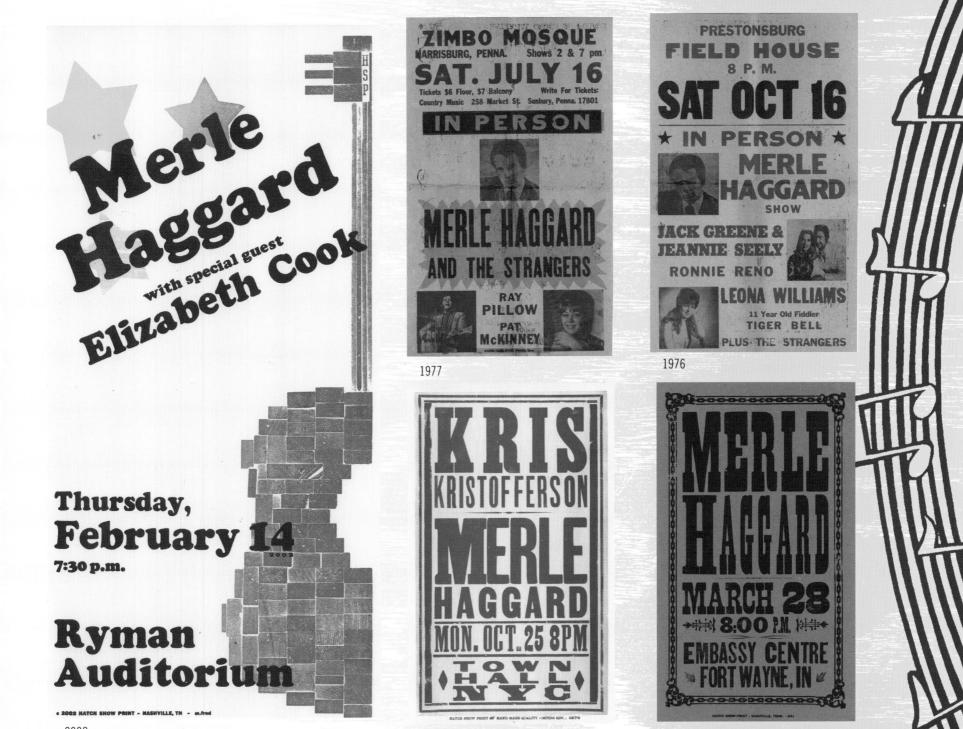

Merle Haggard
with special guest **Elizabeth Cook**

Thursday, February 14
7:30 p.m.

Ryman Auditorium

© 2002 HATCH SHOW PRINT · NASHVILLE, TN · m.fred

2002

ZIMBO MOSQUE
HARRISBURG, PENNA. Shows 2 & 7 p.m.
SAT. JULY 16
Tickets $6 Floor, $7 Balcony Write For Tickets:
Country Music 258 Market St. Sunbury, Penna. 17801
IN PERSON
MERLE HAGGARD
AND THE STRANGERS
RAY PILLOW
PAT McKINNEY

1977

PRESTONSBURG
FIELD HOUSE
8 P.M.
SAT OCT 16
★ **IN PERSON** ★
MERLE HAGGARD
SHOW
JACK GREENE & JEANNIE SEELY
RONNIE RENO
LEONA WILLIAMS
11 Year Old Fiddler
TIGER BELL
PLUS THE STRANGERS

1976

KRIS KRISTOFFERSON
MERLE HAGGARD
MON. OCT. 25 8PM
TOWN HALL NYC

HATCH SHOW PRINT BY HAND MADE QUALITY · CATERS GEN. · 1979

1999

MERLE HAGGARD
MARCH 28
8:00 P.M.
EMBASSY CENTRE
FORT WAYNE, IN

HATCH SHOW PRINT · NASHVILLE, TENN. · BFI

1999

CHARLEY PRIDE

Charley Pride (b. 1934) broke barriers in the 1960s when he became country music's first black superstar.

Born in Sledge, Mississippi, Pride picked cotton as a child so he could buy a Sears Roebuck guitar. Although his area was rich in blues traditions, Pride's father opposed the culture and lyrics of blues music and guided Charley toward listening to country music.

As a young man, Pride served in the army and played professional baseball with the Negro American League. When he injured his throwing arm, he turned to music. His early demo recordings impressed Chet Atkins, who played them for RCA Records officials. Pride's record deal was confirmed before Atkins revealed his race.

On stage, Pride won over listeners with his deep voice, humor, and natural talent. From 1966 through 1989, Pride scored fifty-two Top Ten hits and twenty-nine #1s.

Spokane OPERA HOUSE
SHOWS 7:00 & 9:30 P. M.
SAT. AUG. 16

JACK ROBERTS PRESENTS
CHARLEY PRIDE SHOW
featuring Gary Stewart
Dave Rowland & Sugar

All Seats Reserved At $6.50, $6.00, $5.50, $4.50 Tickets On Sale
Coliseum Box Office P. M. Jacoy's - Bon Marche - Speedy's Record Rack
Produced By Jack Roberts 17522 Bothell Way NE Bothell, Wa. 98011 206 485 - 6511
Hatch Show Print—Nashville

1975

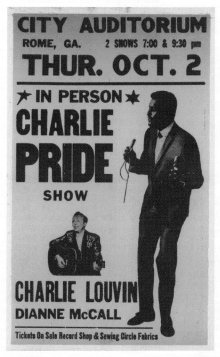

CITY AUDITORIUM
ROME, GA. 2 SHOWS 7:00 & 9:30 pm
THUR. OCT. 2

★ IN PERSON ★
CHARLIE PRIDE
SHOW

CHARLIE LOUVIN
DIANNE McCALL

Tickets On Sale Record Shop & Sewing Circle Fabrics

1969

U. A. C. PRESENTS
THE EVENT OF '77
THE CHARLEY PRIDE SHOW

WITH DAVE & SUGAR
PLUS THE PRIDESMEN

REED GREEN COLISEUM
8 P. M.
SAT. FEB. 12

Tickets $6, $5, $4 On Sale At USM Union, 1st Miss. Nat'l. Bank
Pal's Music in Hattiesburg, Circle C Western Store, Laurel - Citizens Bank
Columbia, All Star Record Shop, Meridian - Gayfers, (Edgewater Mall) Biloxi

HATCH SHOW PRINT—NASHVILLE

1977

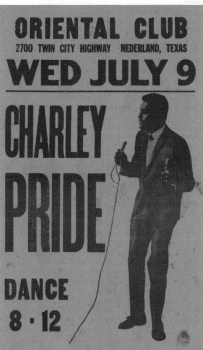

ORIENTAL CLUB
2700 TWIN CITY HIGHWAY NEDERLAND, TEXAS
WED JULY 9

CHARLEY PRIDE

DANCE
8 · 12

1969

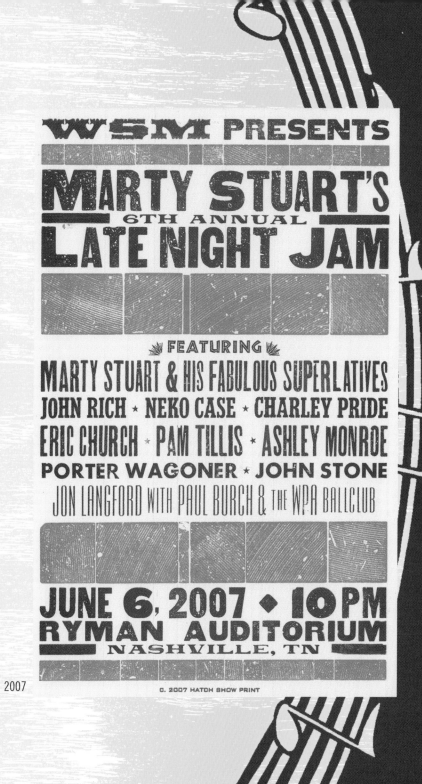

WSM PRESENTS
MARTY STUART'S
6TH ANNUAL
LATE NIGHT JAM

≋ FEATURING ≋
MARTY STUART & HIS FABULOUS SUPERLATIVES
JOHN RICH ★ NEKO CASE ★ CHARLEY PRIDE
ERIC CHURCH ★ PAM TILLIS ★ ASHLEY MONROE
PORTER WAGONER ★ JOHN STONE
JON LANGFORD WITH PAUL BURCH & THE WPA BALLCLUB

JUNE 6, 2007 ◆ 10 PM
RYMAN AUDITORIUM
NASHVILLE, TN

C. 2007 HATCH SHOW PRINT

2007

continued from page 102

From 1992 to 2013, Hatch Show Print remained on Lower Broad, continually shifting gears to keep up with a renewed demand for show posters, as well as artwork for ad agencies interested in the appeal and texture of the distinctly hand-made work the shop offers.

By 2013, the time to move had arrived again. The Country Music Hall of Fame and Museum expanded over an entire city block, adding more exhibit, archive, and event space, and room for Hatch Show Print to reside under the same roof.

Two years of planning went into Hatch Show Print's move, and the specifications from the shop's 116 Fourth Avenue North interior were used as inspiration for the new production facility, at 224 Fifth Avenue South. Only six days of production time were lost—remarkable for the undertaking—and the shop reopened for business on October 13, 2013, with its first print celebrating the move itself.

Hatch Show Print's current home, at 224 Fifth Avenue South. From top: before the equipment was moved in; looking through the front gate; a view through the eighty-foot glass wall that runs the length of the shop.

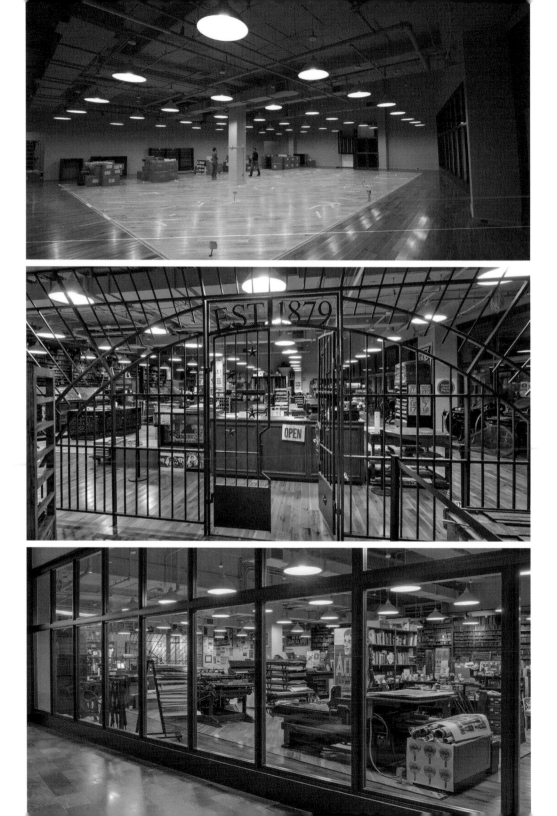

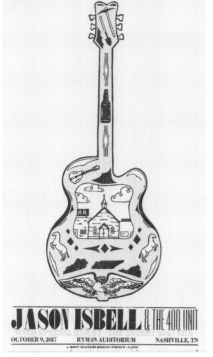

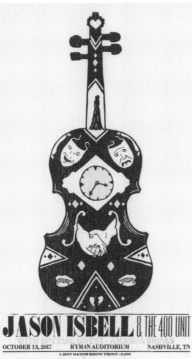

Six distinct posters were printed to celebrate Jason Isbell's six-night residency at Ryman Auditorium in 2017. The designs feature instruments used by Isbell, his band the 400 Unit, and special guest Amanda Shires, along with imagery that represents songs on his album *The Nashville Sound.*

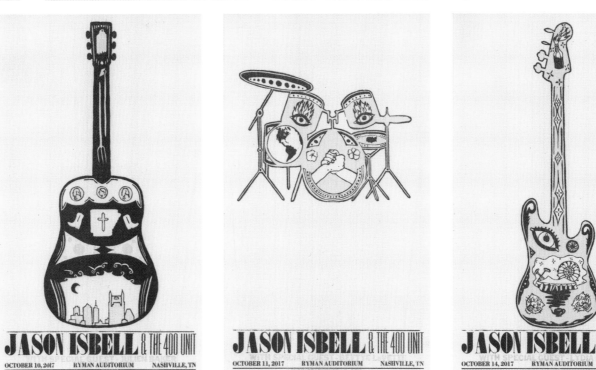

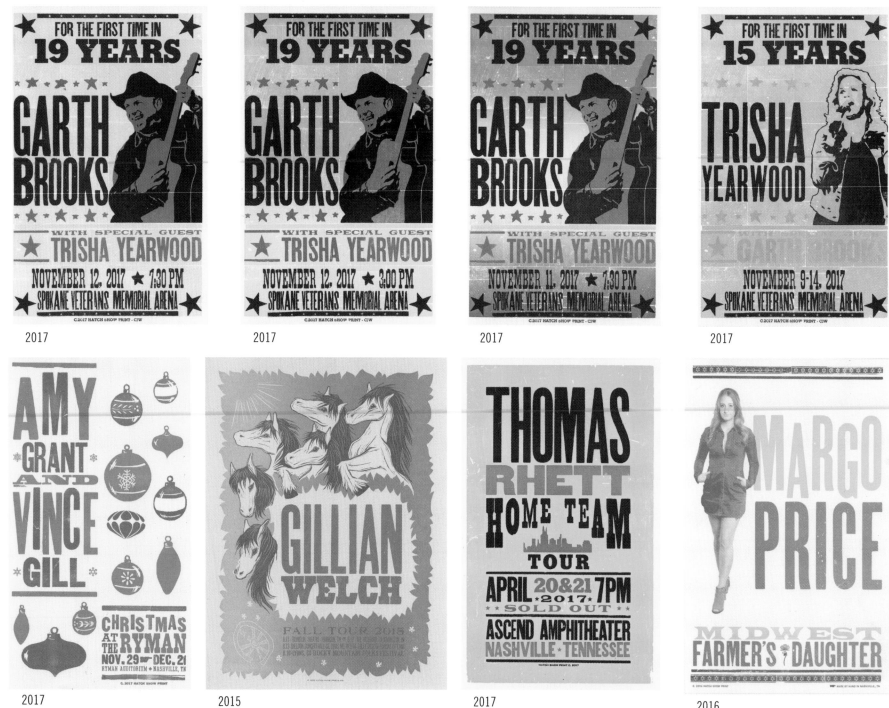

2017

2017

2017

2017

2017

2015

2017

2016

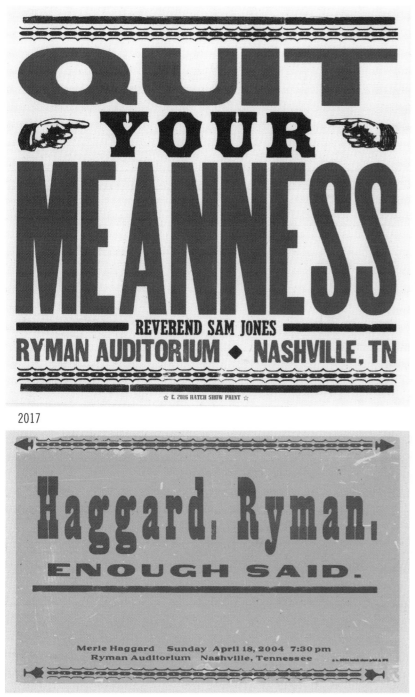

2017

2004

The shop has come full circle. Born in an era when print was the dominant advertising and communication medium, Hatch Show Print excelled at producing visually arresting billboards and posters for millions of advertisements across the country. In the digital age, a vibrant poster can artfully mark a milestone, whether it's a show at Ryman Auditorium, or a citywide event such as the National Football League Draft. More than a century from the shop's beginnings, the design work the Hatch Show Print staff produces celebrates the foundations of an American style of graphic design, and cements its appeal to twenty-first century audiences. Built on paper, ink, and inspiration, the poster endures. ∎

2017

2015

BRETT ELDREDGE'S GLOW LIVE:
A Night of Holiday Hits

DECEMBER 14 + 15, 2018
NASHVILLE ★ TENNESSEE
THE CMA THEATER
AT THE COUNTRY MUSIC HALL OF FAME® AND MUSEUM

2018

GRAND OLE OPRY.
WELCOMES ITS NEWEST MEMBER

JANUARY 21, 2017

★ ★ ★ ★ ★ ★ ★ ★

CRYSTAL GAYLE

2017

Byrds Co-Founders
ROGER McGUINN and CHRIS HILLMAN
Along with Country Music Legend
MARTY STUART and his Fabulous Superlatives
Celebrate the 50th Anniversary of
SWEETHEART OF THE RODEO

October 8, 2018
RYMAN AUDITORIUM
Nashville · Tennessee

2018

HONKY TONK
PORTRAITS OF COUNTRY MUSIC
1972–1981
An Exhibition of Photographs
by Henry Horenstein
©1972 Henry Horenstein

THE SHOW · JULY 8 – AUG 21, 2004
The Print Center · 1614 Latimer St.: between Spruce and Locust
WWW.PRINTCENTER.ORG
THE PARTY · THURSDAY, JULY 8
6:30-8:30 pm at The Print Center Featuring
FRED'S MOBILE HOMES
AFTER PARTY — Drag Night at
Bob and Barbara's Lounge
1509 SOUTH ST · $5
THE BOOKS — Honky Tonk &
Hatch Show Print: The History of a Great American Poster Shop
AVAILABLE AT THE PRINT CENTER

2004

KNOW WHEN TO HOLD 'EM
KNOW WHEN TO **FOLD 'EM**
KNOW WHEN TO **WALK** AWAY
KNOW WHEN TO RUN
WORDS AND MUSIC BY
DON SCHLITZ
NEVER COUNT YOUR **MONEY**
WHEN YOU'RE **SITTING**
AT THE **TABLE**
THERE'LL BE **TIME** ENOUGH
FOR COUNTING ★
WHEN THE DEALING IS DONE

2018

DON & CRAIG HENRY & CAROTHERS

TENN · 2-FBYCR · 2013

2013

KACEY MUSGRAVES
oh, what a world : tour

WITH SINCLAIR
RYMAN AUDITORIUM
2.28.2019
NASHVILLE · TENNESSEE

2019

WHEELS OF SOUL 2016
SUMMER TOUR
TEDESCHI TRUCKS BAND
WITH **LOS LOBOS**
& **NORTH MISSISSIPPI ALLSTARS**

JULY 20, 2016 · Bethel Woods
BETHEL, NY ★ AT THE HISTORIC SITE OF THE 1969 WOODSTOCK FESTIVAL
HATCH SHOW PRINT & C. 2016

2016

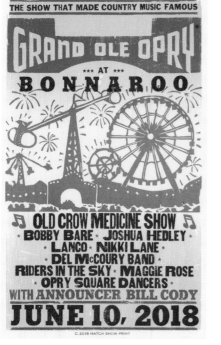

2018

2018

2018

2019

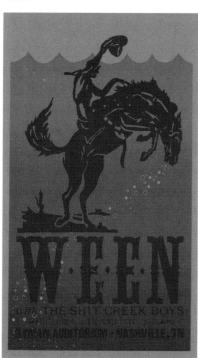

2018

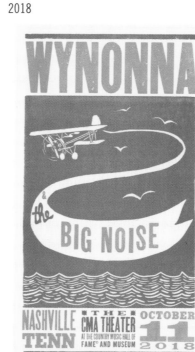

2010

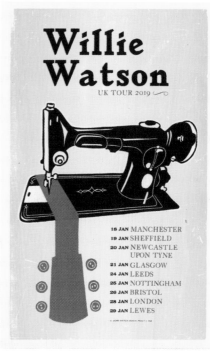

2018

2019

WAYLON JENNINGS

Born in Littlefield, Texas, Waylon Jennings (1937–2002) broke into the music business by working in radio and performing on stage.

Shortly after signing with RCA, he hit with "The Chokin' Kind" and "Only Daddy That'll Walk the Line."

But Jennings chafed under RCA's tight rein. Following his instincts, he cut landmark recordings including the 1973 albums *Lonesome, On'ry and Mean* and *Honky Tonk Heroes*. He was labeled an Outlaw in Nashville for demanding what rock groups had possessed for years: the right to select his own material, recording studio, and musicians.

RCA played up his rebellious image by including Jennings on the 1976 album *Wanted! The Outlaws*, also featuring Willie Nelson, Tompall Glaser, and Jessi Colter.

Jennings's assertiveness helped Nashville recording evolve from a producer-dominated system to one in which artists and producers share power.

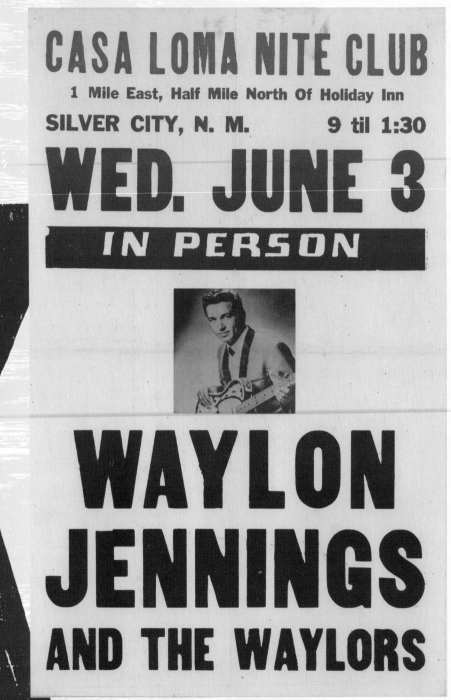

1970

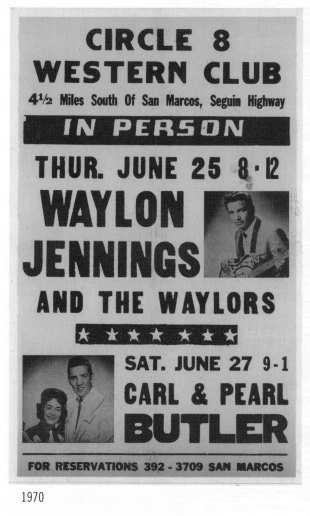

CIRCLE 8 WESTERN CLUB

4½ Miles South Of San Marcos, Seguin Highway

IN PERSON

THUR. JUNE 25 8-12

WAYLON JENNINGS

AND THE WAYLORS

★ ★ ★ ★ ★ ★

SAT. JUNE 27 9-1

CARL & PEARL BUTLER

FOR RESERVATIONS 392-3709 SAN MARCOS

1970

OPERA HOUSE 2 SHOWS 7 & 9:30 pm

SAT JAN 17

ALL SEATS RESERVED $3.00, $3.50, $4.00

Tickets On Sale At Fidelity Lane Ticket Office, 1622 4th Ave.

Kountry KAYO Presents

JANUARY COUNTRY MUSIC SPECTACULAR

RAY PRICE

& CHEROKEE COWBOYS

WAYLON JENNINGS

AND THE WAYLORS

DAVID HOUSTON

& THE PERSUADERS

Produced By Jack Roberts P. O. Box 164 Bellevue, Wash. 98004 Phone 206 455-2600

1969

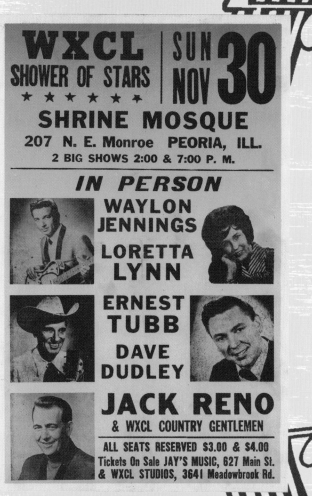

WXCL SHOWER OF STARS

★ ★ ★ ★ ★ ★ ★

SUN NOV 30

SHRINE MOSQUE

207 N. E. Monroe PEORIA, ILL.

2 BIG SHOWS 2:00 & 7:00 P. M.

IN PERSON

WAYLON JENNINGS

LORETTA LYNN

ERNEST TUBB

DAVE DUDLEY

JACK RENO

& WXCL COUNTRY GENTLEMEN

ALL SEATS RESERVED $3.00 & $4.00

Tickets On Sale JAY'S MUSIC, 627 Main St.
& WXCL STUDIOS, 3641 Meadowbrook Rd.

1969

GARTH BROOKS

Garth Brooks (b. 1962) emerged in the 1990s to become one of the biggest-selling music acts of all time. In the process, he helped move country into the mainstream of American entertainment.

Born in Luba, Oklahoma, he grew up in a music-loving family. Brooks heard the traditional country music of Merle Haggard and George Jones from his father and mother; the introspective works of singer-songwriters James Taylor and Dan Fogelberg from his siblings; and the arena-rock dynamics of bands such as Bob Seger and Kiss from his friends.

That combination of bedrock country, sensitive songwriting, and theatrical rock would come together when Garth Brooks hit the world's stage.

After selling more than 100 million albums, Brooks announced his retirement in 2000 to raise his children. He staged periodic concerts and occasionally released new records before fully resuming his career in 2014.

2009

1998

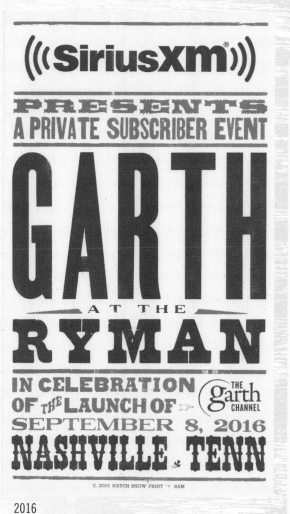

2016

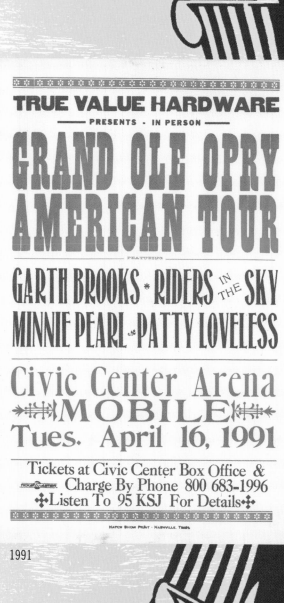

1991

LEARN MORE

BOOKS

Cleeton, Glen U., with Charles W. Pitkin and Raymond L. Cornwell. *General Printing: An Illustrated Guide to Letterpress Printing.* Liber Apertus Press, 2006.

Clouse, Doug, with Angela Voulangas. *The Handy Book of Artistic Printing: Collection of Letterpress Examples with Specimens of Type, Ornament, Corner Fills, Borders, Twisters, Wrinklers, and other Freaks of Fancy.* Princeton Architectural Press, 2009.

Doubler, Michael D. *The Uncle Dave Macon Story.* University of Illinois Press, 2018.

Grushkin, Paul. *The Art of Rock: Posters from Presley to Punk.* Abbeville Press, 2015.

Hayes, Clay. *Gig Posters Volume I: Rock Show Art of the 21st Century.* Quirk Books, 2009.

Hayes, Clay. *Gig Posters Volume 2: Rock Show Art of the 21st Century.* Quirk Books, 2011.

Jury, David. *Letterpress: The Allure of the Handmade.* Rotovision, 2005.

Kelly, Rob Roy. Foreword by David Shields. *American Wood Type: 1828-1900–Notes on the Evolution of Decorated and Large Types.* Liber Apertus Press, 2016.

Moran, Bill, with Robert Style, Dennis Ichiyama, Richard Zauft, and Dave Carson. *Hamilton Wood Type: A History in Headlines.* Hamilton Wood Type and Printing Museum, 2004.

Sherraden, Jim, with Elek Horvath and Paul Kingsbury. *Hatch Show Print: The History of a Great American Poster Shop.* Chronicle Books, 2001.

FILMS

Beckloff, Erin, with Andrew P. Quinn. *Pressing On: The Letterpress Film*, 2017.

Nagan, Justine. *Typeface*, 2009.

WEBSITES

BriarPress.org
(online community and resource website for letterpress printers)

LetterpressCommons.com
(website for letterpress printers and enthusiasts)

PrintingHistory.org
(website of the American Printing History Association)

WoodType.org
(website for Hamilton Wood Type and Printing Museum)

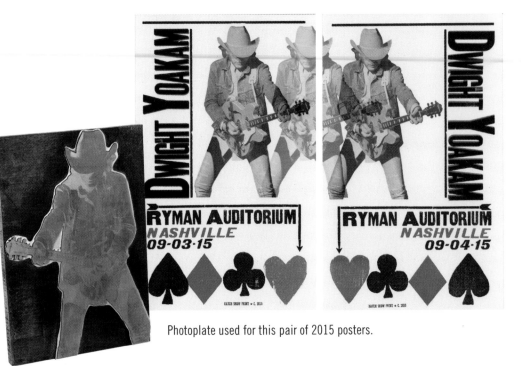

Photoplate used for this pair of 2015 posters.